THE LEDOUX HERITAGE:
THE COLLECTING OF UKIYO-E MASTER PRINTS

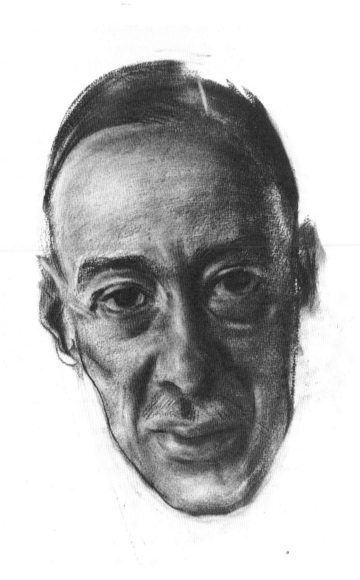

Unfinished portrait in sepia of Mr. Louis V. Ledoux
by Alexandre Yacovlev, May 10, 1936.
Collection of Mrs. Louis V. Ledoux.

THE LEDOUX HERITAGE;
THE COLLECTING OF
UKIYO-E MASTER PRINTS

DONALD JENKINS

JAPAN SOCIETY, INC.

THE LEDOUX HERITAGE: THE COLLECTING OF UKIYO-E MASTER PRINTS
is the catalogue of the exhibition of Japan House Gallery
shown in the fall of 1973 as an activity of the Japan Society, Inc.

Copyright © 1973 by Japan Society, Inc.
Printed in Japan
Library of Congress Catalogue Card Number 73-82970
ISBN 0-913304-02-6

CONTENTS

ACKNOWLEDGEMENTS

This exhibition celebrates the finest of the *ukiyo-e* prints and is a tribute to Louis V. Ledoux, scholar and collector, who did much to lay for this exacting discipline a foundation of connoisseurship upon which we can rely. Poet and businessman, Mr. Ledoux was, as well, an officer of the Japan Society. It is, therefore, appropriate that a significant part of his collection, now dispersed, should be reassembled in the Society's headquarters.

I would like to express a special thanks to Mrs. Louis V. Ledoux, who worked with us in the preparations for the exhibition. Sharing generously of her time and knowledge, guiding us through the intricacies of the history of the Collection, Mrs. Ledoux advised us at every stage of this long process.

Mr. Donald Jenkins of The Art Institute of Chicago, made the selections for exhibitions and authored the catalogue. His task was difficult, and only a scholar of wisdom, insight, and patience could have selected, found, and catalogued so well a body of works dispersed nearly twenty-five years ago. I would also like to thank Mr. Roland Koscherak for his help in letting us freely use his records of ownership for many prints not in public collections. We are most grateful to Mrs. Jackson Burke, Chairman of the Gallery, and to the Founders and Friends whose encouragement and support make possible these exhibitions.

There could be no exhibition at Japan House without loans of art. The lenders to the exhibition have been most cooperative in making available numbers of their most important prints. I would like to express our warmest thanks to all of the institutions and all of the individuals who joined in this show. May I also take this opportunity to thank the fine Gallery staff: Mrs. Maryell Semal, Miss Mitsuko Maekawa, Mrs. Elissa Cullman, and particularly Mrs. Margot Kneeland, who coordinated all aspects of the exhibition. Those who work with us deserve special appreciation: Mr. Kiyoshi Kanai, designer of all our publications; Mr. Cleo Nichols, Mr. Derek Washburn, and Mr. Julius Iten, whose concerns are installation. It has been a pleasure to be associated with these artists.

Rand Castile, Director
Japan House Gallery

LENDERS TO THE EXHIBITION

The Art Institute of Chicago
Mr. and Mrs. James B. Austin
The Brooklyn Museum
Mr. William W. Collins
Miss Edith Ehrman
Ruth Stephan Franklin
Mr. and Mrs. John R. Gaines
Mr. and Mrs. Richard Gale
Dr. David C. Kimball
Mr. Roland Koscherak
H. George Mann
The Metropolitan Museum of Art
The New York Public Library
Mr. Thomas J. Rosenberg
The Toledo Museum of Art
Mr. and Mrs. Edward H. Weinberg

PREFACE

By one of those ironies of fate that Louis Ledoux himself would have appreciated, among the prints brought together for this exhibition are some that have found themselves side by side more than once in the past, only to be separated again at subsequent dispersals. Perhaps there is nothing so surprising in this, since the finest Japanese prints have never been overly abundant, and there have been only a few truly great collections during any one generation. The prints Ledoux collected will always be associated together in our minds, whatever their actual physical separation. In that sense, this exhibition is merely a reminder, not only of things past, but of a reality that will continue to exist over the years.

In 1941, in the Foreword to Part One of his monumental five volume catalogue, Louis Ledoux wrote: "In the past these prints have been loved separately by others; for a moment they are together, dear to me; and before the storms of time scatter them, as well they may, their loveliness should be recorded for the study and solace of those who care for beauty in the years that are to come." There is something immensely moving in these words, reflecting as they do their author's deep conviction that "...he into whose keeping have come for a time works of art that are rare and perishable as well as lovely is merely their custodian and feels it a duty not only to transmit all that he has learned about their meaning but to share likewise with others...the joy that he himself has had in loveliness."

The dispersal that Ledoux had foreseen in 1941 did in fact take place following his death early in 1948. During the intervening years his catalogues have fully lived up to his wishes and have provided material "for the study and solace" of more than one generation of "those who care for beauty." But the catalogues are now long since out of print and, if available at all, enormously expensive. It is also more than twenty years since the collection itself was disposed of. Now seems an opportune moment, before the storms of time blow further, and while there are yet those living who actually knew Louis Ledoux and saw his collec-

tion in its entirety, to bring together once again at least some of the prints he loved and, so doing, to take stock once more of the true measure of his achievement.

The storms of time have not in every case dealt kindly with the Ledoux Collection. New York City is fortunate in that many of the prints found their way into the collections of various public institutions with which Ledoux was associated to a greater or lesser extent during his lifetime, The Brooklyn Museum, where he was a Trustee, The Metropolitan Museum of Art, and The New York Public Library. Many of the prints went to public collections elsewhere as well, to museums in cities like Chicago, Honolulu, Newark, and Toledo, while others were acquired by private collectors who continued to value them much as Ledoux himself did. But some of the prints have truly been scattered, perhaps beyond retrieval, their present owners ignorant of their distinguished provenance. Ledoux knew only too well that Japanese prints are "perishable as well as lovely," and that it is only through the foresight of earlier generations of collectors that they have survived at all. Keenly aware of his own debt to his predecessors, he frequently acknowledged that debt by recording the names of previous owners of his prints. It is lamentable that, for some of the prints, that documentation should now be lost through carelessness or indifference.

Those of us who have organized this exhibition would like to think that Ledoux himself would have approved of our project. In bringing these prints together, we have sought to do more than simply honor the memory of one man, however remarkable. In a sense, it is collecting itself that we have sought to honor. Men become collectors for a variety of motives, not all of them noble. Louis Ledoux's life demonstrates that collecting need not be a form of self-aggrandizement or a mere pastime but that it can be a civilized activity of the highest order, a means of reminding ourselves of our common humanity and of the values that most make us human.

<div align="right">Donald Jenkins</div>

9

LOUIS V. LEDOUX: THE MAN

Louis Vernon Ledoux was one of those rare individuals who are able to combine, apparently without effort, activities and interests that to other men seem totally incompatible. He was a successful businessman, the president of a firm of expert chemists and assayists; he was a poet, with several published volumes to his credit; and, of course, he was a collector and connoisseur of Japanese prints. Yet he wore his accomplishments lightly. By all accounts, he was a person of great charm, with an engaging sense of humor, a man who moved easily in a variety of circles.

He was born in New York City on June 6th, 1880, the only son of the mining engineer and metallurgist, Albert Reid Ledoux. His parents encouraged him from an early age to pursue a variety of interests, among them tennis (he eventually became a first-class player), the out-of-doors (he especially loved the mountains near his family home at Cornwall-on-Hudson), and literature. He was able to continue the liberal education thus begun through his college years at Columbia, where he took courses in both the humanities and science, no major then being required.

After his graduation in 1902, he devoted himself to writing. In 1905 he published his first book of poetry, *Songs from the Silent Land*. This was followed by a second book a year later and yet a third volume in 1907. As a promising young poet, Ledoux soon made numerous friends among artists, musicians and writers. One of these was Edwin Arlington Robinson. Ledoux—or rather the Ledoux, since Louis had in the meantime married Jean Logan of Yonkers—would eventually be of great help to Robinson during several of the more trying periods of the poet's life. Robinson, never very well-off financially, expressed his thanks by leaving the Ledoux his manuscripts. Something of the closeness of this relationship can be gathered from the fact that when Robinson lay dying in 1935, it was to Ledoux and another friend that he entrusted the proofreading of his final book.

Ledoux was a collector of books long before he turned to the collecting of Japanese prints. As a young man he regularly spent Saturday

afternoons in rare book stores and galleries, and his appreciation of good design and fine bindings, developed during those years, is evident in everything he published.

It was through friends and books that Ledoux first encountered the art of Japan. His earliest purchases were landscapes by Hiroshige, which he bought for decoration as much as anything else. Robinson noted them, however, and decided to introduce Ledoux to Howard Mansfield. Mansfield was at the center of a small but active group of New York collectors interested in Japanese prints. Well along in years at the time and childless, he took an immediate liking to Ledoux, whom he treated almost like a son. Under Mansfield's tutelage, Ledoux's interest in the prints developed rapidly. He soon became an active member of the group of New York collectors, which at one time or another included Harold G. Henderson, Sr., Henry L. Phillips, William L. Keane, Frederick Church, Arthur B. Duel, and George Tuttle, among others. The mid-Westerners, Arthur Davison Ficke and Frederick Gookin, were frequent visitors, Gookin especially who, as cataloguer of many of the auctions held in New York during the nineteen-teens and twenties, frequently showed up in the city.

In the fall of 1920, the Ledoux embarked on the first of several trips they would make to Japan and the Far East. It was an idyllic experience. Amply provided with introductions, they found all doors open to them and were able to spend hours going over some of the great private collections of paintings, lacquer, and metal work, a privilege they were quite conscious of and never failed to acknowledge later. In addition through various friends and contacts (Baron Hosokawa, for instance, assigned them a personal guide), they were shown many of the usual famous sights and taken to museums and temples. After leaving Japan, they stopped off in China, at Peking and several of the large coastal cities, then went on to Southeast Asia, for an adventurous visit to Angkor. On the return voyage, they stopped off again in Japan, returning

home in the spring, having acquired a number of paintings and other art objects as well as prints.

If before this trip to Japan Ledoux had had any questions as to where his interests were leading him, the trip must have answered them. Some of his most ambitious purchases were made soon after his return. It was a favorable time to be collecting. Many of the great French collections, formed a generation or so earlier, at the end of the 19th century, when the Japanese print was first "discovered," were beginning to be dispersed; and these collections constituted probably the richest repository of Japanese prints to be found anywhere in the world at that time. Ledoux who, like his fellow American, Gilbert Fuller of Boston, had connections in France, was in a position to take advantage of the sales held there.

Something in the French approach to collecting seems to have appealed to Ledoux from the start. He soon came to know Vignier and Koechlin personally. These two men had been at the very center of Japanese print collecting and *ukiyo-e* scholarship in France. For Koechlin, in particular, who had been Director of the Musée des Arts Decoratifs at the Louvre during the years of the great print exhibitions there (1909-1914), Ledoux seems to have felt something close to veneration; and among his most prized prints were those that had once been in Koechlin's collection.

As Ledoux's interest in the prints intensified, more and more of the energies that he had once applied to his poetry were now absorbed in this new passion. Ledoux's last book of poetry, *The Story of Eleusis, A Lyrical Drama,* was published in 1916. But the poet in Ledoux could not be so easily extinguished. A poet's sensibility underlay his appreciation of the prints; and his writing would retain to the end the descriptive power and sense of cadence that only a born poet can command.

During the twenties and thirties Ledoux was called on repeatediy to organize exhibitions of Japanese prints or write on one or another

aspect of Japanese art. Thus in 1923 he helped organize, and wrote the catalogues for, two exhibitions held at the Grolier Club. In 1927 he wrote *The Art of Japan* for the Japan Society. In 1936 he put on an exhibition of Japanese figure prints for The New York Public Library, drawing the prints entirely from the Library's own holdings. Also in the 1930's he organized with Harold G. Henderson a Japanese print exhibition for the Century Club. An outgrowth of this last project was the most ambitious exhibition he ever worked on, the Sharaku exhibition held in 1939 at The Museum of Modern Art, New York, the Museum of Fine Arts, Boston, and The Art Institute of Chicago. The book that he and Harold G. Henderson wrote to accompany this exhibition, *The Surviving Works of Sharaku,* remains the definitive work on the artist to this day. By consolidating research done separately in this country, Europe, and Japan, then checking the results thus attained against original—and unique— source material in the Museum of Fine Arts in Boston, the two authors were able to bring the work of Sharaku into much sharper focus than ever before. Some of their conclusions were quite startling. "We have apparently conclusive evidence," they wrote, "for believing that the period of his [Sharaku's] productivity comprised only the last ten months of the calendar year 1794." Earlier authors had thought in terms of at least a four or five year period. Some of the excitement the two authors must have felt as they saw where their research was leading them can be sensed in reading the opening pages of their book. Though granting that "the edifice of scholarship never is finished," they still could write, "we believe that the rather startling conclusions to which we have been forced by the evidence obtained cannot be controverted, except perhaps in minor details, by future investigation…"

In 1923 Ledoux had become president of the firm of assayists founded by his father, and he remained active in the business until the last few years of his life. Meanwhile he took on a gradually increasing number of responsibilities growing out of his activities as a writer and collector. He was a major influence in shaping the publication program of the Japan Society, which he had joined already in 1917. In 1933 he became president of the Society for Japanese Studies, a group that, in the words of Eugene Langston, "working closely with a faculty committee at Columbia . . . was instrumental in the institution of formal Japanese studies at the university." Later Ledoux was appointed a member of the New York City Art Commission and a Trustee of The Brooklyn Museum. Several of The Brooklyn Museum's most distinguished prints (including Catalogue Numbers 2, 15 and 53 in this exhibition) were gifts from him.

The Foreword to the first volume of Ledoux's great five volume catalogue is dated May 10th, 1941. It would be difficult to say just when he had first started work on the project, because, in a sense, he had been working on it for at least twenty years. He frequently incorporated in the new work felicitous phrases or, when satisfied that they still seemed apt, entire paragraphs from his earlier writings. Even so, the sheer labor involved must have been enormous. The cost of the undertaking was another concern. Determined that the color plates should convey as much of the loveliness of the prints as possible, he spared no expense in their preparation. To raise the necessary funds, the Ledoux sold their collection of Nò robes to the Metropolitan. Later, as subsequent volumes were readied for publication, yet other sacrifices became necessary, first the sale of the Robinson papers, eventually the sale of the collection itself.

The final years of Louis Ledoux's life were shadowed by two events that would have embittered a lesser spirit. One was the outbreak of the war and the consequent public animosity against everything

Japanese, which threatened, for a time, to undo so much that he had worked to accomplish; the other was a stroke, which left him partially blind and paralyzed, and which must have been especially hard for a man of his energetic temperament to endure. Yet even those dark years had their moments of respite. In 1942, when feelings against the perfidy of Pearl Harbor were at their height, Ledoux was awarded Columbia's University Medal for his writings on the institutions and art of Japan. He was deeply moved by the award, and it must have helped put the true significance of his work into perspective.

During the enforced confinement of his last years, he found solace, and sufficient challenge to occupy a still-active mind, in his collection. He continued to buy. The extraordinary *Mu Tamagawa* set by Shunman (Catalogue Number 35) was not acquired until 1945. What must have been his last purchase was a print he had long known and coveted, an Utamaro (not in this exhibition) which he bought at the Schraubstadter Sale only a month before he died.

THE COLLECTOR AND THE COLLECTION

There is something very special about Louis Ledoux's reputation as a collector. Other collectors—in the early years of this century a great many others—have amassed more prints; others—though fewer by far—have been as fastidious in what they acquired. Gonse, Koechlin, Rouart, Jacquin, and Ficke: these are all names to conjure with in the world of Japanese prints; yet Ledoux more than holds his own in such distinguished company; and it can probably be said that no provenance lends greater *cachet* to a print than for it to have passed through his hands.

How are we to explain this? What is it that seems to set Ledoux, the collector, apart from other collectors? It is largely to attempt an answer to this question that the present exhibition has been organized.

In some ways, Louis Ledoux represents the ideal collector. This is not to say that he never made mistakes but rather that, as a collector, he possessed certain attributes—or perhaps better put, a certain rare balance of attributes—that somehow set him apart from other collectors. Like all great collectors, he loved what he collected, but in his case it was love tempered with knowledge; and though capable of losing his heart to a print, he was also capable of imposing the most rigorous limitations upon himself.

Perhaps nothing else about Ledoux as a collector is so well known as the fact that he deliberately limited the size of his collection to 250 prints. This meant that whenever one print was added, another one had to be taken out, forcing a decision that must often have entailed considerable soul-searching and even, at times, anguish. Yet if working within such self-imposed limits was not always easy, at least it had the advantage of calling the critical faculties into repeated use. Where another collector, with no such limitations to bear in mind, might acquire two, three, even a half a dozen prints without a second thought (provided he had the money), for Ledoux every new acquisition had to justify itself, not only in terms of its relative quality but with regard

to the effect it had on the rest of the collection. Did it lead to an imbalance in favor of one period over another? Did it seem too different from the others, thus attracting undue attention to iself? Such questions could never be far from his thoughts. One is tempted to think that Ledoux was so articulate in writing about prints at least in part because of the rather conscious evaluation of them that this method of collecting required, and because of the continual self-dialogue as to the meaning of his collection that it gave rise to. That he was a poet before he was a collector, and that he brought to everything he did a writer's respect for language, make this no less possible.

Interestingly enough, the idea of limiting the size of his collection, though associated almost exclusively with Ledoux, was not original with him but was a principle followed already by his friend and early mentor in print collecting, Howard Mansfield. Ledoux's decision to follow Mansfield's example had far-reaching consequences, however. It meant that once his collection had attained its maximum size—which it had already by the early 1920's—only internal changes were possible thereafter. That such changes did occur, and were, in fact, extensive, reveals much about Ledoux's philosophy of collecting. He obviously never considered the decision a negative one, one that unduly confined him or that frustrated the collector in him. In fact, as late as 1946, only two years before his death and at a time when he was already suffering from partial paralysis, he could still write (in the Preface to the third volume of his great catalogue) of the continuing "processes of addition and elimination." For Ledoux, to live was to collect, and to collect was to continue as he had begun, by improving the quality of his collection print by print. Seen thus, perhaps it would be better to speak not of his *collection*, singular, but of his *collections*, plural. An analogy with the human body presents itself. There too, though the body ceases to grow in size after a certain age, individual cells continue to multiply, die, and be replaced, so that in middle age the actual physical composi-

tion of the body is quite different from what it had been in youth.

Ledoux himself referred to the changes in his collection as a "slow process of sublimation." It would be revealing to follow the workings of this process year by year, but unfortunately the necessary documentation is not available. Early in his career as a collector, however, Ledoux wrote two catalogues which, though only some of the prints described in them were his, afford revealing insights into his taste at that time. They were the catalogues of two exhibitions held at the Grolier Club in 1923, the first consisting of 125 figure prints, the second of a like number of landscape and bird-and-flower prints. Ledoux lent thirty prints to the figure print exhibition and Howard Mansfield lent sixty. The other lenders were Frederick Church and Dr. Arthur B. Duel. The four men were close friends and often met together to discuss and compare their prints. The idea for the Grolier Club shows must have originated at one of these sessions. Ledoux, the poet, was of course the obvious choice for writing the catalogues.

In keeping with a long-standing tradition at the Grolier Club, the catalogues made no mention of lenders' names; so there is no way of knowing who lent a particular print. Presumably, however, the two exhibitions reflected the strengths and weaknesses of the several lenders' holdings. One can assume, for instance, that there were twelve fine Kiyonagas at least in part because that artist was so well represented in the Mansfield Collection. In this respect, it is interesting to note that, even with the combined resources of the four collections to draw upon, there were only nineteen Primitives in the figure print exhibition. Though several of these were Ledoux's (including Catalogue Number 11 in this exhibition), his collection was still a long way from the days when it could boast six Kaigetsudōs of its own, not to speak of the many other distinguished Primitives acquired in later years from the Fuller and Garland collections.

Ledoux had already published several books of poetry when he began work on the Grolier Club catalogues, but his only previous publication on *ukiyo-e* had been a small article, "Pathfinding in Paradise, The Poems on Japanese Prints," written in 1921. For a first effort, the Grolier Club catalogues are impressive indeed. The descriptions of individual prints, though nowhere as extensive as those he would write later, were still, considering the standards of the period, models of judicious appraisal and careful scholarship. Twenty years later Ledoux would find himself satisfied enough with some of the passages to repeat them word for word in the five volume catalogue of his collection.

What we are most interested in now, however, is what the Grolier Club catalogues have to reveal about Ledoux's taste—about his whole approach to *ukiyo-e*—as he sought to articulate it at the time. We can then compare his earlier views with those he expressed later and thus gain some insight into how his taste changed.

Take Kiyonaga, for instance, to whom Ledoux seems never to have been especially drawn. When he began collecting the weight of critical opinion was against him. Arthur Davison Ficke, whose *Chats on Japanese Prints*, published in 1915, had become one of the standard books on the subject, reserved his highest praise for that artist, extolling him in terms that now sound rather high-flown and extravagant but that at the time were apparently regarded as the "last word." Everyone seemed to agree that Kiyonaga represented the culmination of the classical figure print, and twelve of the 125 prints in the first Grolier Club exhibition were by him. Even so, a certain reserve, however carefully qualified, seems evident in Leudox's discussion of him in the catalogue:

> *Kiyonaga is considered by many the greatest of the artists who designed the Japanese figure prints. In power of composition, power of line, he is superb, and his people are stately, large-*

limbed, nobly-proportioned, gracious. Compare any print by him with a print by Harunobu and notice the gain and loss. It is a grown-up world that is depicted here, more real, perhaps, than the other; less charming and more impressive. Of the impressiveness of Kiyonaga there can be no question; he was a master of his art. One admires him more than Harunobu—and loves him less.

Ledoux found some of these words still valid enough to repeat *verbatim,* twenty or so years later, in his "Bunchô to Utamaro" catalogue; but his reservations, meanwhile, had become more pronounced, and after conceding that there can be no question of Kiyonaga's impressiveness "at his best," he went on to point out some of the artist's defects: "...sometimes his figures are too statuesque, too placid;...sometimes he forgets the value of blank spaces and overfills his sheets." At his death, Ledoux had only four prints by Kiyonaga. Years of experience had given him the sense of confidence that "any authentic collection must of necessity reflect the idiosyncracies of the collector."

As Kiyonaga fell in Ledoux's estimation, Utamaro rose in it. Here again Ledoux took a position at variance with that held by most critics of his generation. Ficke, for instance, following Fenollosa, placed Utamaro among the "decadents," and described his most characteristic figures as "emanations" of a "feverish mind." At first Ledoux seemed to accept this point of view. In the 1923 Grolier Club catalogue he wrote of Utamaro thus:

Unquestionably a great artist, he gave his art, he gave his life to the "Flowers of Yedo," as the courtesans in their gorgeous robes had come to be called; and as his power worked toward its premature decline he drew them with ever increasing exaggeration of figure and of pose, more and more like blooms of the jungle and morass, never such blossoms as filled the spring-time orchards of Harunobu or climb the wind-swept hillsides of Japan.

But it was a point of view with which he could not feel comfortable for long. Later he would write that, though what he had said earlier was "at least partly true," it was "perhaps mainly an echo of de Goncourt's book which devoted so much space to Utamaro's treatment of scenes in the Licensed Quarter and of Fenollosa's attempt to aggrandize Kiyonaga by calling his great successor 'decadent.'" "He has been called a great decadent," he wrote, but "the greatness is ever apparent whereas the decadence, when it appears at all, brings merely a momentary regret that the exquisite loveliness of a *fin de siecle* art can only attain its own perfection through the loss of an earlier virility." The Ledoux Collection eventually contained more prints by Utamaro than by any other figure artist except Harunobu.

It seems clear that as his knowledge—and the number of prints that had passed through his hands—increased, Ledoux felt a growing sense of confidence in his own judgement. Large-scale shifts of emphasis within the collection, though difficult to trace, must have occured as a result. Yet a collection, especially one like Ledoux's, is put together work by work, by means of a series of individual decisions. How did Ledoux arrive at these decisions? What criteria did he apply?

He once listed four considerations to be borne in mind in selecting a print: 1) distinction of subject; 2) excellence of impression; 3) excellence of condition; and 4) loveliness of color. On the surface these seem ordinary enough, the sort of thing that any collector might be expected to take into account. Where Ledoux differed, however, was in the relative *weight* he placed on each of these considerations. For him, distinction of subject outweighed almost everything else; a distinguished design, if sufficiently rare, might be worth acquiring even if faded or stained or in some other respect less than flawless. Though fastidious, Ledoux was not the sort to make a fetish of condition, and the collection showed this.

Where Ledoux was at his best was in sensing those elusive factors that set the great prints apart from the merely beautiful ones. It was there that he was at his most creative. No one—at least no Westerner—has ever equalled him in his sensitivity to the nuances, to all the delicate but easily dispelled poetry of the prints; no one, in short, has ever had a surer sense of what truly constitutes "distinction of subject" in *ukiyo-e*.

Ledoux knew that "in the Orient a grain of sand may really represent the Universe, and like a stone thrown into still water, any thought may produce ripples that stretch out to an infinite distance and break at last on shores as unexpected as they are remote." Such "overtones," he once wrote, " may be in almost any print and it is seldom safe to assume too hastily that they are not." Knowing this, Ledoux also knew that even the least detail in a print had its significance. A poem was no mere embellishment, but a clue to further meanings, and even the pattern on a costume could be part of a rich texture of associations. It was insight of this order that allowed Ledoux to see the philosophic grandeur implicit in designs as seemingly simple as Catalogue Numbers 3 and 24. It was his capacity for insight of this order that lies at the basis of the respect that even today Ledoux's name continues to enjoy.

Though Ledoux's approach was initially that of the collector—that of the *amateur* in the French sense of the word—his influence on *ukiyo-e* scholarship was profound. By insisting on the importance of detail, not for pedantic reasons, but as a means to more thorough appreciation, he created an entirely new concept of the well-written catalogue. It is probably safe to say that every major *ukiyo-e* catalogue published in the West during the last twenty years follows to some degree the standards that Ledoux set.

One aspect of collecting that has always held great importance for almost every collector is the friendships that it gives rise to. Such friendships are apt to be particularly cherished where the number of

those devoted to the same pursuit is small, as it has almost always been with Japanese prints. There is a distinct pleasure in discovering that others, whose backgrounds and personalities otherwise are totally different from one's own, share one's taste for certain kinds of rare and beautiful objects; and the rarer the objects, the more select the company of those interested in them, the more emphatic is one's pleasure. Collecting can be a highly competitive activity, but the extent to which such friendships can survive the inherent rivalry involved is surprising. Ledoux obviously enjoyed the friendships he made through collecting. These were, as mentioned earlier, not only with fellow collectors, however, but with curators and scholars also, and included Europeans and Japanese as well as Americans. In fact there was hardly a figure of any consequence associated with the Japanese print during his lifetime with whom he was not acquainted, at least through correspondence if not on a face-to-face basis.

Of course by all accounts Ledoux was an eminently *sociable* person, one for whom collecting could never be a solitary activity. He enjoyed learning from others and sharing with them; such experiences, in fact, were part of the very substance of collecting as he saw it. In *The Art of Japan,* a book he prepared for the Japan Society in 1927 (and dedicated, by the way, to Howard Mansfield), Ledoux wrote of the Paris collectors he admired so much and obviously took as his ideal:

> *In Paris a group of distinguished men, fast aging now, many of whom have been known as authorities on the arts of other lands, have dined together on one evening of each month for over forty years, and after dinner the bare, almost squalid room of the cafe where these "Friends of Japanese Art" are wont to meet, is transformed as out of packages and pockets emerge objects which brought to their finders that release from the prisoning troubles of life which is the gift of art—objects that are passed down the long table as reverently and lovingly as*

they would have been handled above the clean straw mats of a tea-ceremony room in the land from which they came.

One cannot help but sense how much Ledoux, who could have taken his place with ease in that distinguished company, felt the lack of a similar group in New York, where at that time, there was even apparently something of a prejudice against Japanese art. One feels that in writing *The Art of Japan* he was motivated, at least in part, by a desire to see a comparable fellowship arise in his native city.

Ledoux was aware that he owed much to his fellow collectors. Because he thought of collecting as a sociable activity, it seemed only natural to him to refer to the circumstances in which he had first seen a print or to evoke the memory of those who had once owned it. This helps explain the care with which he occasionally documented the provenance of a print. To whatever meaning a work of art had when it first appeared, to all the rich cargo of associations it carried with it from the start, were added yet other associations connected with those who had treasured it since then. For Ledoux these too were important; a print, after all, was a fragile thing; that it had survived at all was something of a miracle. He who had been perceptive enough to see the beauty in a print and who had valued it enough to rescue it from oblivion deserved special praise.

UKIYO-E

The Japanese word for prints such as Ledoux collected is *ukiyo-e*, literally "pictures of the floating world." To go into the origins of this word and its original Buddhist connotations would be out of place in an essay like this. A working definition, however, certainly seems in order, especially as not all *ukiyo-e* are prints, nor are all Japanese prints *ukiyo-e*.[1] There are *ukiyo-e* paintings, for instance; in fact, historically, such paintings appear on the scene *before* the prints. What makes both the paintings and the prints *ukiyo-e*, "*pictures* of the floating world," is subject matter and style.

For all the severity of its rule, the Tokugawa Shogunate (1615-1868) brought Japan an era of unaccustomed peace and prosperity. It also introduced a money economy which, supplanting the earlier economy based on barter and feudal obligations, led to the rise of an independent urban middle class of merchants and artisans. This new class grew rapidly in literacy and self-awareness and soon produced forms of literature, theater, and the arts which, though based on traditional models, were uniquely their own: *kabuki, bunraku*, the novels of Saikaku (1642-1693), and *ukiyo-e*. Though popular, in the sense that they addressed themselves to the concerns of the class for which they were produced, these forms were as demanding in their own terms, as concerned with esthetic effect, as any of their classical prototypes.

The subject matter of *ukiyo-e*, especially *ukiyo-e* prints, is relatively limited. Basically, at least in the early 18th century, there were only two kinds of subjects: actors and beautiful women; and, indeed, there is a sense in which these always remained the chief preoccupation of the figure print. Masanobu, with his parodies of classical themes, and Harunobu, with his childlike lovers, are only partial exceptions. Not until later, really not until the 19th century, was the repertory enlarged with the addition of landscape and the more varied subject matter of *surimono*. Erotic subjects, though rarely seen in public collections, were also common in *ukiyo-e*. Much of the finest work of Moronobu and Sugimura

1. Buddhist images, printed from woodblocks, were known in Japan many centuries before the first *ukiyo-e*.

Jihei is erotic in nature. Catalogue Number 1, for instance, is a so-called "cover sheet" from an erotic album.

The first *ukiyo-e* prints began to appear in the final quarter of the 17th century. Printed in black and white only, color, if present at all, was added by hand later. The earliest hand-colored prints are known as *tan-e*, "*tan* pictures" because of the extensive use they made of *tan*, red lead.

Some of the most imposing of all *ukiyo-e* are the large vertical *sumizuri-e* (uncolored prints) and *tan-e* brought out in the first two decades of the 18th century. Such prints (Catalogue Numbers 2, and 4-10) have an intensity, a forcefulness, and a sense of scale that set them apart from anything done later. Their vogue, however, was brief, ending about 1718; and today they are exceedingly rare.

Most of the prints brought out in the next two decades were in the smaller *hosoban* (or *hoso-e*) format. They are almost all colored by hand and are known, depending on the palette used, as either *urushi-e* or *beni-e* (see Glossary). These are often very charming works, and several distinguished artists are known almost exclusively by their production in this mode. By comparison, however, the period seems to represent a definite falling off from the creative power apparent at the beginning of the century.

Another major change in *ukiyo-e* occurred around 1740. New formats were invented, the *hashira-e*, or pillar print, and the wide *hashira-e*, and something of the generous scale of earlier prints was regained. Some of the most perfect of the so-called Primitives—certainly some of the most studied in terms of design (Catalogue Numbers 13 and 14, for example)—date from this period.

The development of the first *printed* color occurred at about this time, around 1745. In the beginning, the color range was limited to a pink derived from the safflower, *beni*, and green. Eventually other colors were added to these so-called *benizuri-e*, but the first true full-color

prints do not appear until twenty years later and are associated with the sudden emergence of Harunobu.

The bulk of Harunobu's production dates from only a six year period, from 1765 to his death in 1770. His influence, however, was enormous, and for a time all *ukiyo-e* seemed to follow the fashion he set. His prints are almost all either in the new *chûban* format he popularized or in the *hashira-e* format. His figures are delicate and childlike and are placed in circumstances or settings that often evoke passages in classical Japanese literature. Many of his prints, in fact, incorporate entire poems, either in separate cartouches or in stylized cloud-forms.

If Harunobu seemed to direct *ukiyo-e* away from its former pre-occupation with the stage and the pleasure quarters, the effect was only temporary. Shunshô, whose early work shows a marked Harunobu influence, soon turned almost exclusively to actor prints; and Koryûsai, some of whose early prints can hardly be distinguished from Harunobu's own, devoted himself increasingly to the depiction of courtesans.

The 1780's mark the classic phase of the Japanese print. Kiyonaga, whose stately women have a repose and statuesque beauty all their own, is the representative artist of this period, though Shunman and Shunchô also each occupy an important position within it. All three men were masters at the effective placement and grouping of figures.

If the 1780's could be characterized as the "classic" decade of *ukiyo-e*, the 1790's can be characterized as the "brilliant" decade. These were the years when Chôki, Sharaku, and Utamaro were creating their most striking work. There is something daring and at the same time extremely stylish about the prints of this period. Cropping, unexpected angles of vision, close-ups, were all devices that were either invented or that first attained real popularity at this time, while the vogue of the bust portrait, which reached its height around 1795, allowed artists to make rich capital of the elaborate coiffures then in fashion. The most effective device employed in this period, however—the most brilliant

in a very literal sense—was the mica background.

Figure prints continued to be made, in ever increasing numbers in fact, during the 19th century; but distinguished designs were few and standards of execution actually declined. Ledoux, like most collectors of his generation, felt that with the turn of the century the great age of the figure print had past.

With landscape prints it was another matter. Apart from a few so-called perspective prints, the landscape print is wholly a phenomenon of the 19th century. Various factors contributed to this development: greater travel and a consequent growth of interest in familiar landmarks and famous sights; the influence of European landscape prints with its greater emphasis on realism; and a more widespread familiarity with certain aspects of Chinese landscape painting.

Though a number of artists worked in landscape at this time, the most memorable designs were created by two men, Hiroshige and Hokusai. Both men also produced many *kachô*, bird-and-flower prints. Though prints of this kind had been known earlier (e.g., Catalogue Numbers 30 and 32) and drew, in fact, on a tradition going back all the way to the Sung Dynasty in China, they attained fresh popularity in the hands of these artists.

The changes in Japan that attended its opening up to the West in the 1860's meant the end of *ukiyo-e*. It could not outlive the institutions on which it was based.

The Ledoux Collection included one print that, strictly speaking is not *ukiyo-e*. It is the charming print of mice by the lacquer artist and *surimono* designer of the Shijô School, Zeshin. Dating from well into the second half of the 19th century, after Japan had already absorbed the first brunt of westernization, it stands as a reminder that not all was lost with the disappearance of *ukiyo-e*, that esthetic integrity of a high order survived.

1 **Hishikawa Moronobu**
LOVERS IN AN OUTDOOR SETTING
ôban album sheet, 11½ x 13½ inches (23.5 x 33.7 cm.), *sumizuri-e*
No Signature; No Seals
Date: 1680's
The Metropolitan Museum of Art, Harris Brisbane Dick Fund, 1949

Probably no other design by Moronobu has been more widely admired than this one, and truly it is a superb composition, with its delicate play of line set off against massed areas of black and its gentle, pastoral lyricism. It is the cover sheet from a *shunga* album of twelve prints.

Former Collection: Ficke
Reproduced: Ficke, *Chats on Japanese Prints*, Pl. I; Ledoux, *Primitives*, No. 4; Lane, *Masters of the Japanese Print*, Pl. 20; Gentles, *Masters of the Japanese Print*, No. 5; Stern, *Master Prints of Japan*, No. 3; Jenkins, *Ukiyo-e Primitives*, No. 8

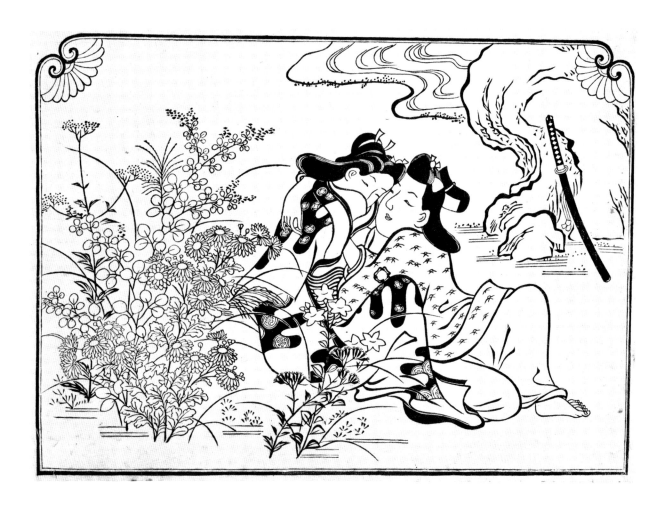

2 Attributed to Torii Kiyonobu I
THE ACTOR NAKAMURA GENTARÔ IN AN UNIDENTIFIED ROLE

kakemono-e, 20 x 12 inches (50.8 x 30.5 cm.), *sumizuri-e*
No Signature; No Publisher's Marks
Collectors' Seals: Wakai Oyaji and Shisei zô
Date: ca. 1700-1705
The Brooklyn Museum, Gift of Louis V. Ledoux

The rotundity of the figure, which fills the sheet almost to its edges, is typical of Kiyonobu's early work, as is the stoutness and exuberant size of the patterns in the costume—the fleshy chrysanthemum leaves, for instance, or the thick bamboo shoots. The sash tied around the waist and the cord of the hat contribute to this same general impression, to which the dainty hands, the tiny, *zôri*-clad foot, and the slender staff afford a somewhat amusing contrast. Ledoux dated this print to ca. 1713, apparently on the basis of the scanty records concerning the dates of Gentarô's appearances on the Edo stage; but on stylistic grounds it should definitely be dated earlier.

This print, along with several others—among them some of the most distinguished prints in the collection—was acquired from Gilbert Fuller of Boston.

Former Collections: Sekine Shichibei, Wakai, Doucet, Fuller
Reproduced: Vignier and Inada, *Primitives,* No. 28; Ledoux, *Primitives,* No. 7

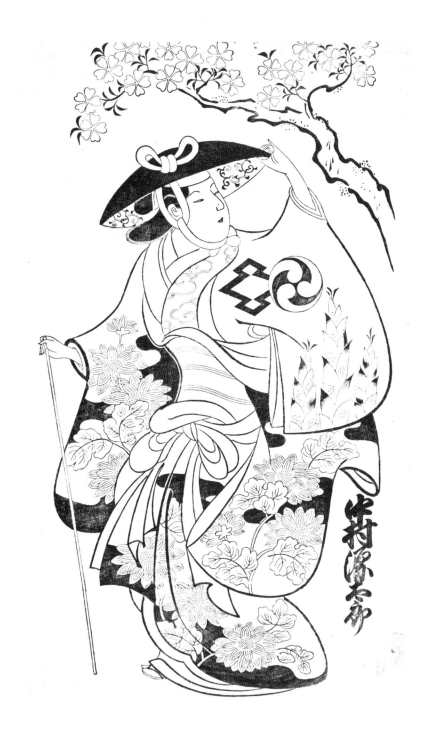

中村源六郎

3 Attributed to Torii Kiyomasu
THE COURTESAN MONAKA READING A POEM

hosoban, 12¼ x 6 inches (31.1 x 15.2 cm.), colored by hand in *tan* and greenish yellow
No Signture; No Artist's Seal
Publisher: Yamashiroya
Date: ca. 1712
The Metropolitan Museum of Art, Harris Brisbane Dick Fund, 1949

The poem, that part of it that is visible, reads *Inochi mo uttoshi keredo, mado no ume...* "Life is full of trouble, but the plum-blossoms by the window..." The name of the house to which Monaka belonged, Myôgaya, and its address, Kyômachi, Hidarigawa, appear at right and her name is given at the left. Ledoux had acquired this print already by the early 1920's and it remained a favorite of his throughout his life. As he said of it, "There is a peculiar stateliness about the design, a dignity that is unusual in a print of this size." It is conceived on a scale that could be easily enlarged to *kakemono-e* size. But what especially attracted Ledoux to this print was something more. "Even if we disregard the sweep of line in the print itself," he wrote "and the artistic mastery that was capable of suggesting spacious magnificence in so small a picture, the little poem, breathed like a sigh, makes this portrait of a girl of long ago worthy of admiring attention for if it leads the mind out from thoughts of dead ladies and the snows of yester-year to the innate ability of the Orient to open vast horizons with a word or a stroke of the brush." This is a classic instance of Ledoux's sensitivity to what might be called the "overtones" in a print. As he once said, "Japanese prints have no frames. Thought is not confined in them but is led out from them..." For Ledoux, the mention of "the plum-blossom by the window," suggesting as it does "a philosophy of life in which nature is seen as an alleviation, a recompense," gives the print an added significance that might well escape the casual viewer.

Reproduced: Ledoux, *Grolier Figure Print Catalogue,* Pl. II; Ledoux, *Primitives,* No. 11

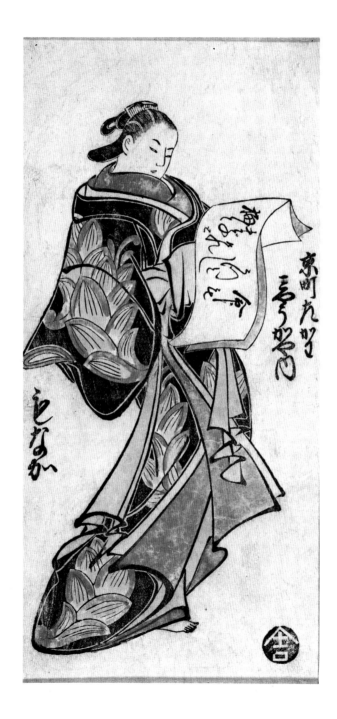

4 **Torii Kiyomasu**
BEAUTY WALKING TO THE RIGHT

kakemono-e, 22½ x 12¼ inches (57.2 x 31.1 cm.), *sumizuri-e*
Signature: Torii Kiyomasu; Seal: Kiyomasu
Collectors' Seals: Wakai, Oyaji and (at top and bottom) Nobu (?)
Publisher: Nakajimaya Sakai-chô
Date: ca. 1712
The Metropolitan Museum of Art, Harris Brisbane Dick Fund, 1949

A comparison of this print with No. 2, on the one hand, and with Nos. 5 through 10, on the other, will reveal the extent to which, by the second decade of the 18th century, even the Torii artists had begun to come under the pervasive influence of the Kaigetsudô School. Note the calligraphic sweep of line and the nodule-like swellings where the lines abruptly change direction. The total effect, however, is lighter and more playful than the somewhat more brittle designs of the Kaigetsudô masters. The jar-shaped seal, half of which is impressed sidewise at the bottom of the sheet and half of which appears at the top, has been found on several other Torii School *kakemono-e* of this period, but there is no record of whose seal it was.

This is another of the distinguished prints acquired from Gilbert E. Fuller of Boston.

Former Collections: Wakai, Doucet, Fuller
Reproduced: Vignier and Inada, *Primitives,* No. 69, U.T., Vol. II, No. 20; Ledoux, *Primitives,* No. 12

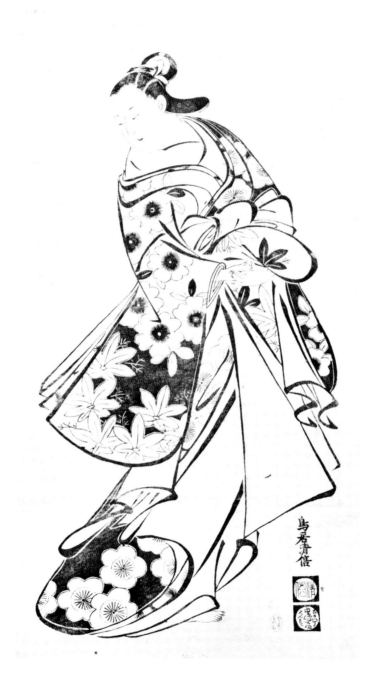

37

5 Kaigetsudô Anchi
WOMAN WALKING TOWARD THE RIGHT

kakemono-e, 22¾ x 12¾ inches (57.7 x 32.4 cm.), *sumizuri-e*
Signature: Nihon giga Kaigetsu matsuyô Anchi zu, "An amusing picture in
Japanese style drawn by Anchi, a 'last leaf' of Kaigetsu;" Seal: Anchi
Collector's Seal: Takeuchi zô in
Publisher: Maruya Kihachi, Ôdenma-chô Nichôme Higashi Yoko-chô
Date: ca.1714
The Metropolitan Museum of Art, Harris Brisbane Dick Fund, 1949

For a brief moment in the history of *ukiyo-e,* during the second decade of
the 18th century, the painter Kaigetsudô Ando and his pupils seemed to reign
supreme, and it was as though every other *ukiyo-e* artist worked in their
shadow. The designs they created have a power and authority never equalled
later. The subject matter is almost always the same, a courtesan, generally
standing alone, seemingly abstracted or aloof, and robed in voluminous gar-
ments. The outlines and folds of the garments are rendered in taut, bold,
painterly strokes. The artists' signatures are conspicuous, spidery, eccentric.

By bringing together six Kaigetsudô prints, Ledoux succeeded in making
himself the envy of collectors the world over. The extent of his accomplish-
ment cannot be appreciated, however, unless one knows that only thirty-nine
Kaigetsudô prints have ever been recorded, and that many of those, includ-
ing two of these six, exist only in unique impressions.

Five of Ledoux's six Kaigetsudô prints had once belonged to the great French
connoisseur Raymond Koechlin. The story of how Koechlin had found them,
folded up together in an album in a small bookstall beside the Seine, has since
become famous, the discovery ranking as probably the greatest "find" in the
entire history of Japanese print collecting. Though Ledoux knew Koechlin
and had doubtless seen the prints during one or another of his several visits
to Koechlin's home on the Quai de Béthune, they did not pass directly into
his hands. Four of them went to Gilbert Fuller of Boston and the fifth to H. P.
Garland to Seco, Maine. Ledoux acquired the Garland print in 1936. I have
been unable to determine when he acquired the four Fuller prints.

Former Collections: Takeuchi, Koechlin, Fuller
Reproduced: Ficke, "The Prints of Kwaigetsudo," page 112; U.T., Vol. II, No.
41; Ledoux, *Primitives,* No. 14; Stern, *Master Prints of Japan,* No. 6

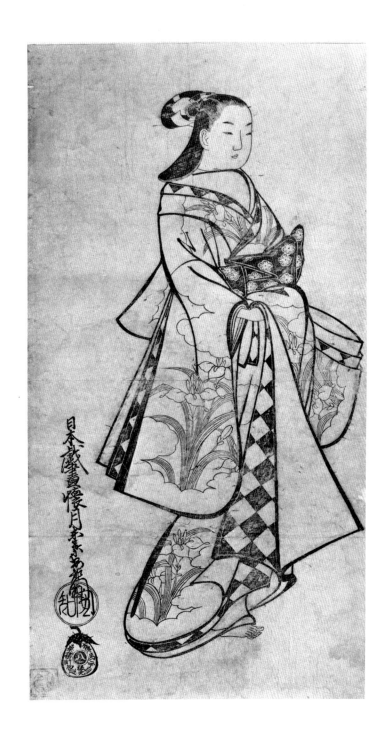

39

6 **Kaigetsudô Dohan**
BEAUTY LOOKING OVER HER SHOULDER
kakemono-e, 22¼ x 12 inches (56.5 x 30.5 cm.), *sumizuri-e*
Signature: Nihon giga Kaigetsu matsuyô Dohan no zu, "An amusing picture in Japanese style drawn by Dohan, a 'last leaf' of Kaigetsu;" Seal: Dohan
Publisher: Igaya, Motohama-chô
Collector's Seal: Takeuchi zô in
Date: ca. 1714
The Metropolitan Museum of Art, Harris Brisbane Dick Fund, 1949

There is something superb in the way this figure turns, almost disdainfully, to look back at someone or something behind her. She has allowed her outer robe with its woven fence and flower design to slip from one shoulder, revealing a rich, striped kimono underneath, and has gathered up the excess length of her garments, clutching it in front of her. The crisp dark blacks in this print are especially effective.

Former Collections: Takeuchi, Koechlin, Fuller
Reproduced: Ficke, "The Prints of Kwaigetsudo," p. 106, U.T., Vol. III, No. 36; Ledoux, *Primitives*, No. 15; Gentles, *Masters of the Japanese Print*, No. 34; Jenkins, *Ukiyo-e Primitives*, No. 119

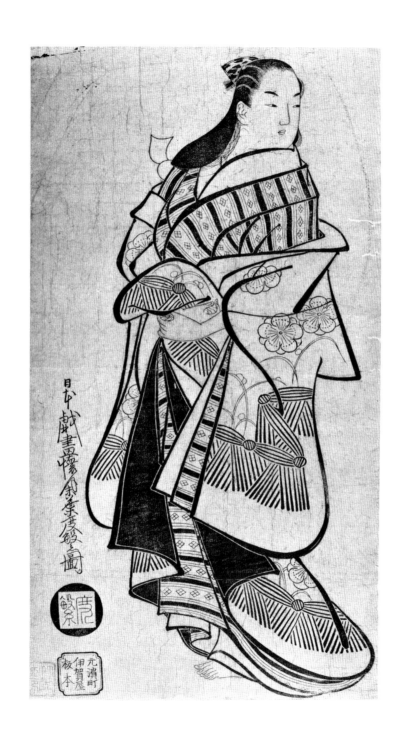

7 Kaigetsudô Dohan
COURTESAN WITH UPRAISED SLEEVE

kakemono-e, 24⅛ x 12½ inches (61.3 x 31.7 cm.), *sumizuri-e*

Signature: Nihon giga Kaigetsu matsuyô Dohan zu, "An amusing picture in Japanese style drawn by Dohan, a 'last leaf' of Kaigetsu;" Seal: Dohan

Collectors' Seal: on face of print, at lower right, H. C. (Crzellitzer); on the back of the print, Hô Su Kaku-in, collector's seal of Kobayashi Bunshichi

Publisher: Igaya, Motohama-chô

Date: ca. 1714

The Metropolitan Museum of Art, Harris Brisbane Dick Fund, 1949

This is a less formidable, less brittle, design than the preceding one, and the figure seems more vulnerable somehow as she turns to look behind her, her sleeve raised to her chin, in a gesture that is frequently seen in paintings by the Kaigetsudô artists. Once again, as in the preceding print, the courtesan has freed one arm from the sleeve of her outer kimono.

This is the one Kaigetsudô print that did not come originally from the Koechlin Collection.

Former Collections: Kobayashi, Crzellitzer, Schraubstadter

Reproduced: Schraubstadter Catalogue (1921), Pl. XIX; Ficke, "The Prints of Kwaigetsudo," p. 102; Mills College Catalogue, Pl. 34; Ledoux, *Primitives*, No. 16

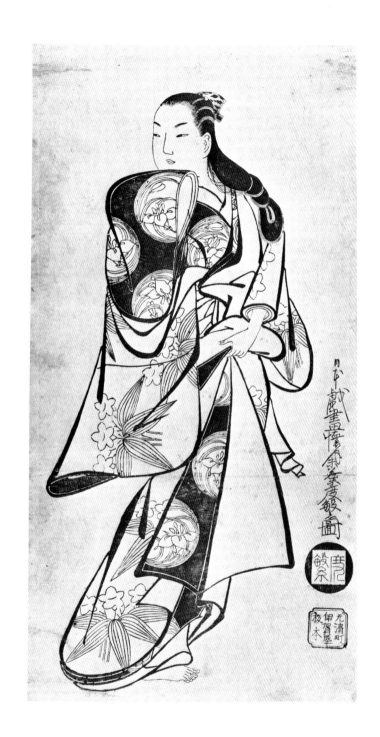

43

8 Kaigetsudô Dohan
COURTESAN READING A POEM SLIP

kakemono-e, 23½ x 12½ inches (59.2 x 31.7 cm.), *sumizuri-e*
Signature: Nihon giga Kaigetsu matsuyô Dohan no zu, "An amusing picture
in Japanese style drawn by Dohan, a 'last leaf' of Kaigetsu;" Seal: Dohan
Collectors' Seal: at lower right, Takeuchi zô in; at lower left, undecipherable
No Publisher's Mark
Date: ca 1714
The Metropolitan Museum of Art, Harris Brisbane Dick Fund, 1949

The Japanese have long been known for their responsiveness to nature and
their sensitivity to the changing seasons; so it is not surprising that in each
of the twenty-two known designs by Kaigetsudô artists some allusion is made
to a specific and separate time of year. Here the pine and bridge motif of
the kimono pattern refers to New Years

The poem is decipherable and reads: *Asa yù o/Sanae ni wakuru/Mitsuru
kami/Sôban-sôban to/Sôban-sôban to,* "Morning and evening, I part my ra-
vaged hair, thin as rice sprouts, and wonder when he will come."

Former Collections: Takeuchi, Koechlin, Fuller
Reproduced: Ledoux, *Primitives,* No. 17; Gentles, *Masters of the Japanese
Print,* No. 36; Stern, *Master Prints of Japan,* No. 4; Jenkins, *Ukiyo-e Primi-
tives,* No. 118

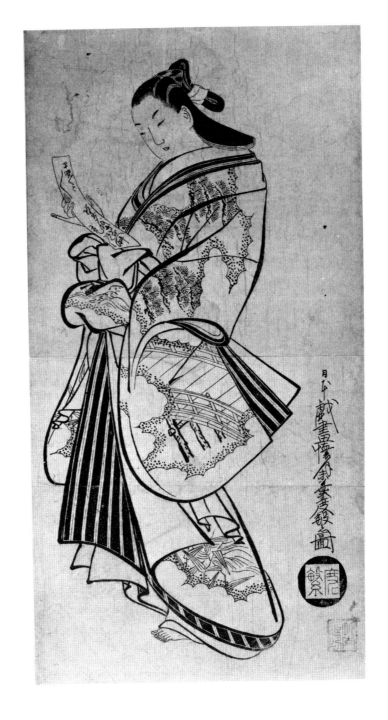

45

9 **Kaigetsudô Doshin**
COURTESAN WALKING TO THE LEFT

kakemono-e, 23½ x 12½ inches (59.7 x 31.7 cm.), *sumizuri-e*
Signature: Nihon giga Kaigetsu matsuyô Doshin zu, "An amusing picture in
Japanese style drawn by Doshin, a 'last leaf' of Kaigetsu;" Seal: Doshin
Collector's Seal: Takeuchi zô in
Publisher: Nakaya, Tôri Abura-chô
Date: ca. 1714
The Metropolitan Museum of Art, Harris Brisbane Dick Fund, 1949

The kimono design, of large hawk feathers and tassled cords (of the kind
hung from the perches of hunting falcons), is unusually simple and bold.
The seasonal reference is to September, the month of falconry.

Former Collections: Takeuchi, Koechlin, Fuller
Reproduced: Ledoux, *Primitives*, No. 18; Gentles, *Masters of the Japanese
Print*, No. 38; Stern, *Master Prints of Japan*, No. 7; Jenkins, *Ukiyo-e Primitives*, No. 110

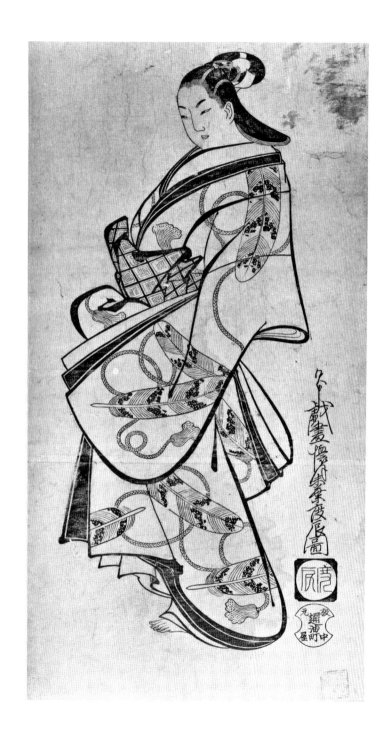

47

10 **Kaigetsudô Anchi**
COURTESAN PLACING A HAIRPIN IN HER HAIR
kakemono-e, 22¾ x 12¾ inches (57.8 x 32.4 cm.), *sumizuri-e*
Signature: Nihon giga Kaigetsu matsuyô Anchi zu, "An amusing picture in Japanese style drawn by Anchi, a 'last leaf' of Kaigetsu;" Artist's Seal: Anchi
Collector's Seal: Takeuchi zò in
No Publisher's Mark
Date: ca. 1714
The Metropolitan Museum of Art, Harris Brisbane Dick Fund, 1949

No other impression of this print is known. For pure loveliness and elegance it has no equal among the surviving prints of the School. The kimono pattern, with its happy contrast between the growing chrysanthemum above and the wave-borne chrysanthemum flowers below, is especially graceful and open. The pose, both arms upraised to adjust the hair and insert a pin, was much favored by the Kaigetsudô artists and is frequently found in paintings by them.

Former Collections: Takeuchi, Koechlin, Garland
Reproduced: Ficke, "The Prints of Kwaigetsudo," Pl. 111; U.T., Vol. II, No. 38; Ledoux, *An Essay on Japanese Prints*, Pl. I; Ledoux, *Primitives*, No. 19; Gentles, *Masters of the Japanese Print*, No. 33; Stern, *Master Prints of Japan*, No. 5; Jenkins, *Ukiyo-e Primitives*, No. 107

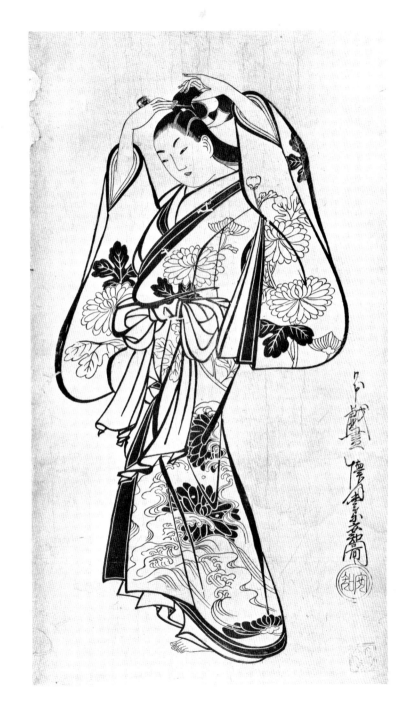

49

11 Okumura Masanobu
BURNING MAPLE LEAVES TO HEAT SAKE

ôban, 16½ x 12 inches (41.9 x 30.5 cm.), *benizuri-e*
Signature: Hôgetsudô Tanchôsai Okumura Bunkaku Masanobu ga; Seals:
Tanchôsai and Masanobu
Date: ca. 1750
The Metropolitan Museum of Art, Harris Brisbane Dick Fund, 1949

Masanobu was unusual among *ukiyo-e* artists of his generation in the extent
to which he drew on older, more classical traditions for his subject matter.
Here three women, attired as guards of the Imperial Gardens, make up an
elegant maple viewing party. One of the women has begun to copy a poem
by the Heian poet Ki no Tsurayuki (884-946 A.D.), *Kokoroshite kaze no
nokoseru...,* "Mindful of what the wind has left,,," To the left is a complete
seventeen syllable poem, *Irozuku ya/Momiji o taite/Sake no kan*, which
Ledoux rendered as "More brilliant grow the colors of maple leaves burning
under sake kettles." The entire mood of the print is one of courtly refinement
and nostalgia for an aristocratic past; there is nothing of the Yoshiwara or
the *kabuki* theater.

Reproduced: Ledoux, *Primitives*, No. 26; Gentles, *Masters of the Japanese
Print*, No. 47; Stern, *Master Prints of Japan,* No. 28

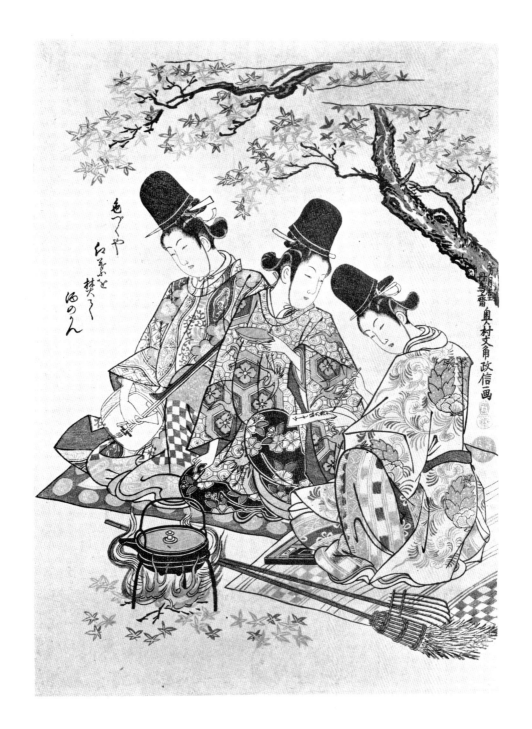

12 Attributed to Ishikawa Toyonobu
A DANDY

hosoban, 12½ x 6 inches (31.7 x 15.2 cm.), colored by hand in greenish yellow, bright yellow, *beni*, purple and gold
No Signature; No Publisher's Marks
Date: ca. 1728
The Metropolitan Museum of Art, Harris Brisbane Dick Fund, 1949

An appealing print and obviously a favorite of Ledoux's, this was included already in the Grolier Club show of 1923 (where it was attributed to Toshinobu) and was reproduced in color in the *Primitives* catalogue of 1941. Ledoux refers to the dandy as being "of more than questionable morals," a delicate way of describing him as a *wakashu* or fashionable young homosexual. He is recognized as such by the tight-fitting cap he wears over the shaved forepart of his hair. Caps of this sort were affected not only by *wakashu* but also by *onnagata*, male actors of female roles, as it disguised one of the most obvious emblems of masculinity in a society in which there were few distinctions between the sexes in dress. The youth's raincoat, decorated with the crests of various popular actors and fitted with a high collar and frogs, is as fanciful in its way as some of the clothing worn in the late Middle Ages in Europe. Ledoux's attribution to Toyonobu has much to say for it, though arguments could certainly be made for attributions to Toshinobu or Shigenaga. Ledoux based his opinion on "the poise, the sweetness of expression and the delicacy of drawing," which he considered characteristic of Toyonobu and which are unquestionably present in this print.

Reproduced: Münsterberg, *Japanische Kunstgeschichte*, Vol. III, p. 319; Ledoux, *Primitives*, No. 34; Stern, *Master Prints of Japan*, No. 36

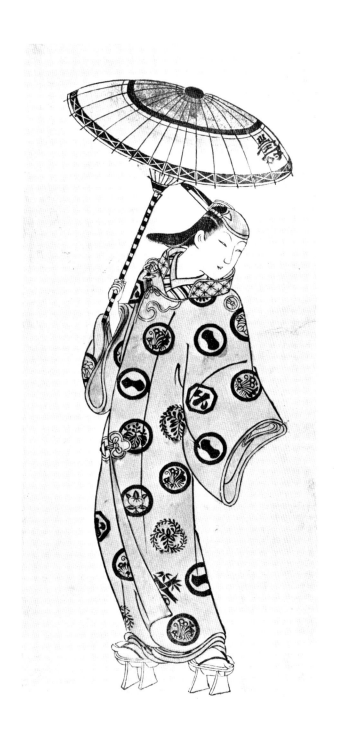

53

13 Ishikawa Toyonobu
A YOUNG WOMAN IN SUMMER ATTIRE

large *hashira-e*, 19¾ x 9 inches (50.2 x 22.9 cm.), hand colored
Signature: Tanjôdô Ishikawa Shûha Toyonobu zu; Seals: Ishikawa uji and Toyonobu
Publisher: Urokogataya
Date: ca. 1748
The Metropolitan Museum of Art, Harris Brisbane Dick Fund, 1949

Toyonobu was a master at creating designs for the *hashira-e* format. The long, narrow shape, even of wider variants like this one, inevitably presented the artist with something of a challenge. Here Toyonobu has met the challenge admirably by actually emphasizing the vertical elements of the composition, making the door post at the right center the axis against or around which all other elements of the design are grouped. The time represented seems to be a hot evening in summer. The woman stands listlessly in the doorway, holding a fan and lantern. Everything in the picture seems to wilt or droop in the still, humid air.

Former Collection: Hirakawa
Reproduced: Hirakawa Catalogue (1917), frontispiece; Ledoux, *Primitives*, No. 39; Stern, *Master Prints of Japan,* No. 39

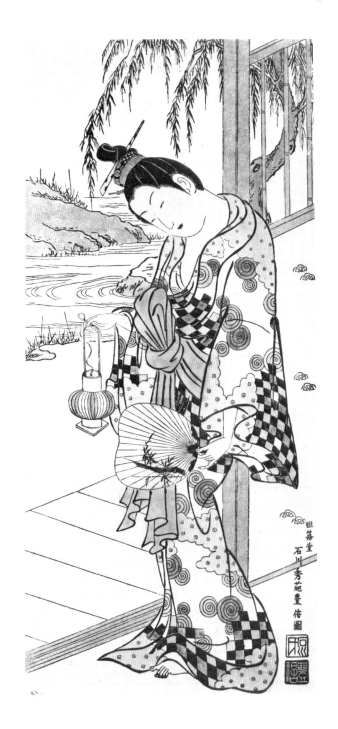

55

14 Ishikawa Toyonobu
**THE ACTOR SANOGAWA ICHIMATSU WITH A FOLDED
LOVE LETTER**

large *hashira-e*, 24 x 9¾ inches (61 x 24.7 cm.), hand colored
Signature: Tanjòdò Ishikawa Shùha Toyonobu zu. Seals: Ishikawa uji and
Toyonobu
Publisher: Urokogata ya
Date: ca. 1743
The Metropolitan Museum of Art, Harris Brisbane Dick Fund, 1949

Another distinguished *hashira-e* by Toyonobu, this one showing the popular
young *kabuki* actor, Sanogawa Ichimatsu. Wearing a coat of the checked
pattern he made famous, and which even today bears his name, he turns to
look back to his right and seems to be about to pass a folded love letter, pre-
viously secreted under his sleeve, to someone outside the frame of the picture.

Reproduced: Ledoux, *Primitives,* No. 40; Stern, *Master Prints of Japan,* No. 40

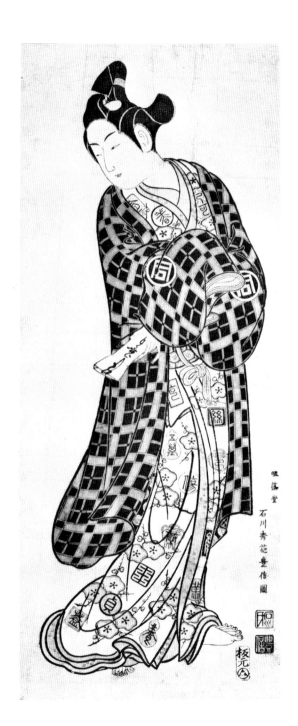

15 Torii Kiyohiro
NAKAMURA SHICHISABURÔ II AS SUKEROKU AND NAKAMURA TOMIJÛRÔ AS AGEMAKI

ôban, 16¾ x 11½ inches (42.5 x 29.2 cm.), *benizuri-e*
Signature: Torii Kiyohiro hitsu. Seal: Kiyohiro
Publisher: Hôsendô Maruya, Tôri Abura-chô
Date: 1753
The Brooklyn Museum, Gift of Louis V. Ledoux

One forgets that two actors are represented here and sees instead, as the theater audience would have, two flower-like lovers walking side by side under a partially closed umbrella. Emblazoned on the umbrella, however, are the respective *mon* of the two actors. Ledoux considered this "a print of great distinction with its simple rose and green almost perfectly preserved," but felt that "one might have loved it better if the birds and the clappers and the cords from which these are hung had been left out." *Benizuri-e* of this size are quite rare. Masanobu designed a few (see No. 11), but the type is more frequently associated with Toyonobu and Kiyohiro. This print was not sold with the rest of the collection, having been given by Ledoux to The Brooklyn Museum, where he was a Trustee, a month before he died.

Reproduced: Ledoux, *Primitives*, No. 45

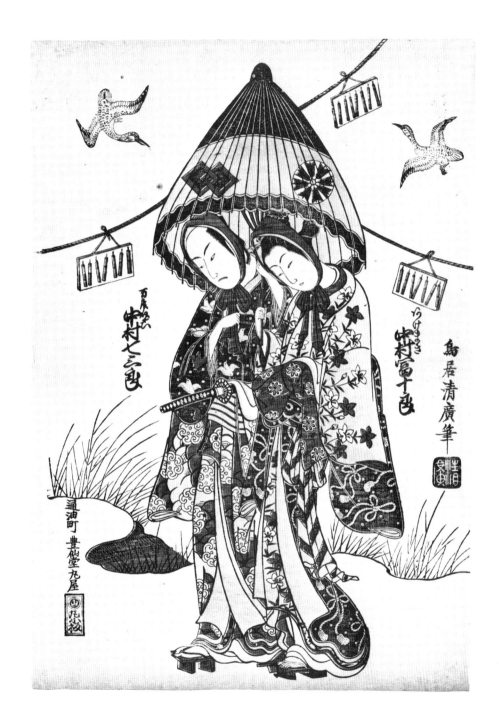

16 **Torii Kiyomitsu**
AZUMA TÔZÔ I IN THE PLAY "OTOKOYAMA YUNZEI KURABE "

hosoban, 12¼ x 5½ inches (31.1 x 14 cm.), *benizuri-e*
Signature: Torii Kiyomitsu ga
Publisher: Nishimura ya, Bakurô-chô Nichôme
Date: 1768
The Metropolitan Museum of Art, Harris Brisbane Dick Fund, 1949

If the traditional date for this actor print is right, it was brought out several years after the development of full-color printing, yet the basic color scheme is still that of the *benizuri-e.* A comparison (even if somewhat unfair, since the roles depicted are so different) with No. 26, a nearly contemporary work by Shunshô, will show how conservative this print is. Where the Shunshô is all close-up dramatic intensity, here the conventional aspect is still strong— the stage property-like tree, the tableau-like pose of the actor, the obtrusive trade-mark of the publisher. The design is delicate and graceful, however, and—though this would not be immediately apparent to the Westerner—witty as well. The characters used as a design on the actor's *haori* read *uguisu,* the Japanese "nightingale," a bird traditionally associated in Japan with plum blossoms, which appear here as the design on the actor's kimono. The cages, of course, make yet another, more direct, reference to birds, and the role portrayed is that of the spirit of a falcon disguised as a woman. All this gives just a glimpse of the levels of meaning and complexity of allusion to be found in even the most seemingly simple print.

Reproduced: Ledoux, *Grolier Figure Print Catalogue*, Pl. IX; Ledoux, *Primitives,* No. 47

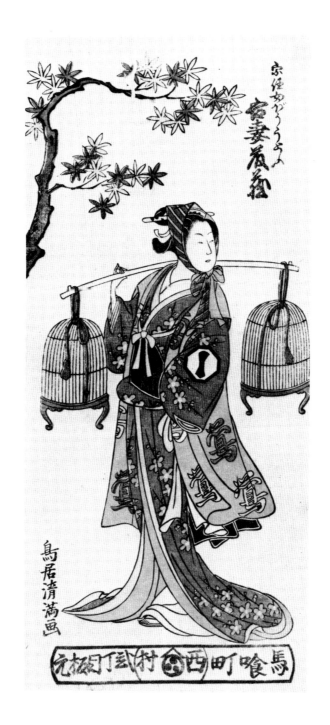

17 **Attributed to Suzuki Harunobu**
A YOUTHFUL COUPLE REPRESENTING JÔ AND UBA

chûban diptych, 11¼ x 8¼ inches (28.6 x 21 cm.) each sheet
No Signature; No Seals
Date: 1765
Mr. and Mrs. Richard Gale

The old couple of Takasago, traditional symbols of long-continued marital felicity, are usually shown with rake and broom on a sandy beach. Here a youthful couple (Harunobu seems to have had an aversion to depicting old age) stand either in a room or on a stage, in front of a pair of sliding screens. The pine tree painted on the screens is another symbol of venerable old age. Ledoux felt that the delicacy of printing so evident here was intended to create the effect of moonlight, and this certainly seems possible, though, if so the ambiguity of the setting becomes even more pronounced. There is something haunting and rarified about this work that is virtually imparalleled in *ukiyo-e*. This is a so-called calendar print, meaning that symbols for the various long and short months whose combination would give a specific year (in this case, Meiwa 2; i.e., 1765) are worked, puzzle-fashion, into parts of the figures' costumes. Harunobu provided designs for a large number of these during the first two years of full-color printing.

As far as is known, this is the only complete version of the diptych extant. Ledoux treasured the print not only for its rarity and intrinsic beauty, but for its associations with its former owner, his friend, the distinguished collector, Miss Louisa Langdon Kane.

Former Collections: Fenollosa, Kane
Reproduced: Ledoux, *Harunobu and Shunshô*, No. 4; Hillier, *Gale Catalogue*, No. 65; Hillier, *Harunobu Catalogue* No. 18; Narazaki, *Zaigai Hihô, Harunobu,* No. 9

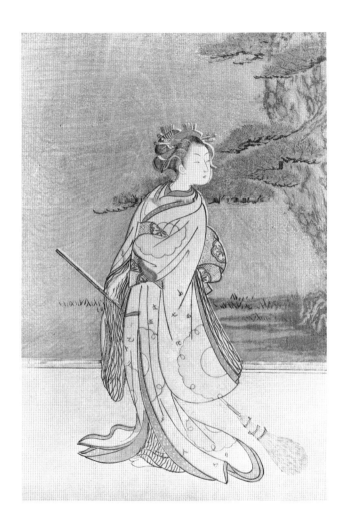
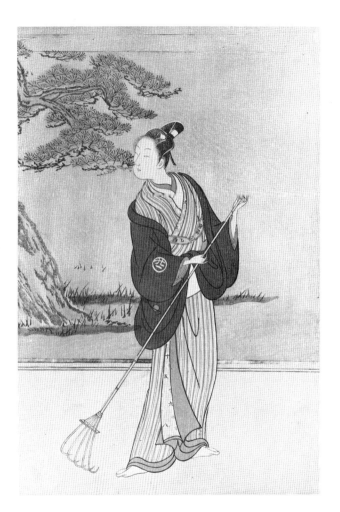

18 Suzuki Harunobu
YOUNG WOMEN SEATED BEFORE A MOSQUITO NET

chūban, 11 x 8¼ inches (28 x 21 cm.)
No Signature
Collector's Seal: Hayashi
Date: 1766
Prints Division, The New York Public Library, Astor, Lenox, and Tilden
Foundation

A design of great elegance and of a suavity unusual for Harunobu. The brilliance with which the loose folds of the girl's robe and the ample billows of the mosquito net are contrasted with the geometric clarity of the *shōji* and the floor lamp at the right reminds one of Utamaro. The colors, predominantly pearl gray and pale yellow, are handled with deftness and restraint.

Another collector might have been disturbed by the stains on this print; but for Ledoux, never one to place condition above distinction of subject or excellence of impression, they were of little consequence.

This is another calendar print. Symbols indicating Meiwa 3 (i.e., 1766) appear on the fan and in the girl's *obi.* There is some dispute as to precisely what the girl is doing here. Some maintain that she is holding her hands to her ears to keep out the sound of thunder; others believe that she is smoothing her hair and listening for the approaching footsteps of her lover.

There are four seals and a handwritten inscription on the back of the print, probably all dating from the 18th century. One of the seals, at any rate, has been identified as belonging to one of the members of the Kyosen coterie which commissioned so many Harunobu calendar prints.

Former Collections: Hayashi, Haviland
Reproduced: Haviland Catalogue (November 1922), No. 42; Noguchi, *Harunobu,* Pl. 20; Ledoux, *Harunobu and Shunshô,* No. 11

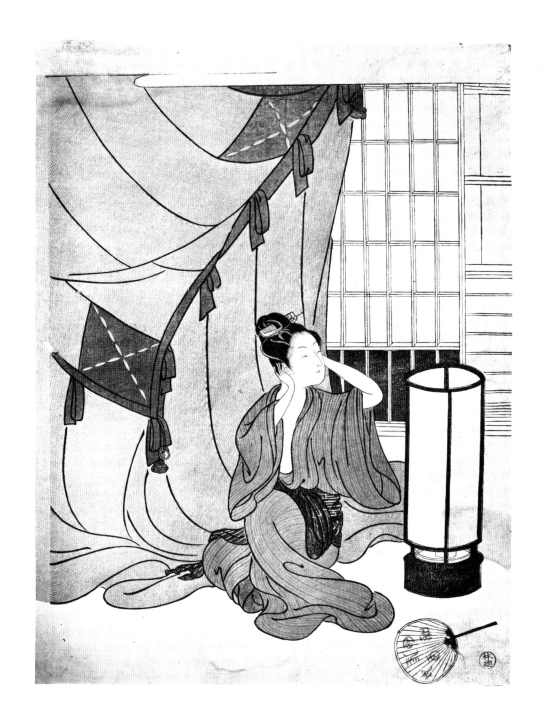

19 Suzuki Harunobu
GI, "JUSTICE" OR "RIGHTEOUSNESS"
from the series: "The Five Cardinal Virtues," *chūban*, 11¼ x 8½ inches (28.5 x 21.6 cm.)
Signature: Suzuki Harunobu ga (on sliding door)
Date: 1767
Miss Edith Ehrman, New York

This is one of the most remarkable impressions of this print extant. The pinks and blues, normally the first to fade, have remained unchanged while "happy accidents of oxidation have veiled the usual strong tone of the sliding door and darkened the Chinese white of the background." Another interesting side effect of the oxidation is that it draws attention to the two flickering candles and makes it more obvious than in other impressions that a night scene was intended.

Illustrated manuals of etiquette and moralizing storybooks were quite common at the time. Indeed Harunobu himself illustrated several of them. The young man kneeling on the floor seems to be reading one of these, which he holds open at a particularly edifying scene. Other signs of the print's instructional intent are also in evidence. The panel of calligraphy over the door reads *Jun, Yoku,* "obedience, order," while the cartouche at the upper right gives a poem elaborating on the meaning of *Gi: Nanigoto mo/Mi o herikudari/Ri o wakachi/Itsuwari naki o/Gi to wa yūbeki,* "Be humble in all things, Follow reason and do not deceive; That is righteousness."

Reproduced: Ledoux, *Harunobu and Shunshō,* No. 16; Stern, *Master Prints of Japan,* No. 52

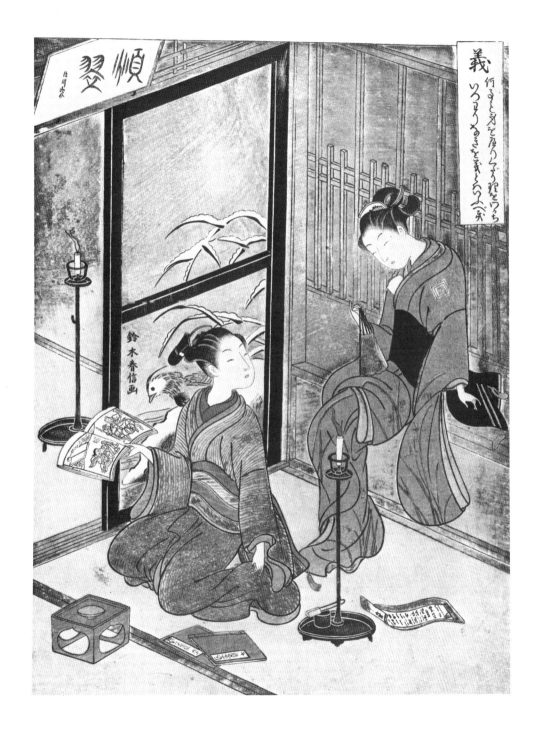

20 Suzuki Harunobu
TWO GIRLS ON A WINDY DAY
chûban, 10¾ x 8 inches (27.3 x 20.3 cm.)
Signature: Suzuki Harunobu ga
Date: ca. 1767
Mr. and Mrs. Richard Gale

As mentioned earlier, for Ledoux distinction of subject frequently outweighed all other considerations when deciding whether or not to retain a print. This is an excellent case in point. Writing about it, he said: "There has been a little retouching around the edges of the hats, for the register had become imperfect through wear in the delicate lines of the blocks, and neither in engraving nor condition is the print beyond reproach; it is, however, among Harunobu's best compositions, the rich black of one of the kimono giving distinction to the windblown grace of the whole picture."

Reproduced: Noguchi, *Harunobu*, Pl. 80; Ledoux, *Harunobu and Shunshô*, No. 18; Hillier, *Gale Catalogue*, No. 79; Narazaki, *Zaigai Hihô, Harunobu*, No. 48

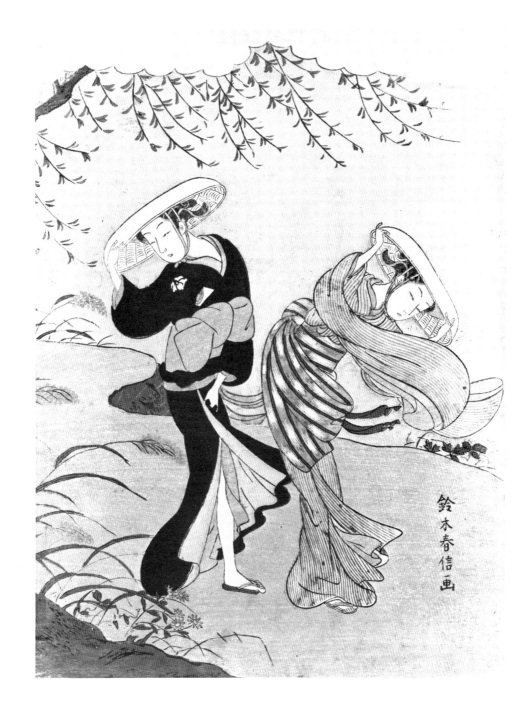

21 **Attributed to Suzuki Harunobu**
A GIRL DIGGING UP BAMBOO SHOOTS

chûban, 11 x 18 inches (28 x 20.3 cm.)
No Signature; No Seals
Date: ca. 1765 (an earlier state was a calendar print for 1765)
Mr. and Mrs. Richard Gale

This young woman approaching a clump of bamboo shoots with a mattock represents Môsò, one of the "Twenty-four Paragons of Filial Piety." According to the moralizing legend, Chinese and Confucian in origin, Môsò sought to satisfy the craving of a sick parent by going out in the snow to seek bamboo shoots which, miraculously (it being the dead of winter), he found. Prints like this, which translate or parody classical themes, are known as *mitate-e.* Harunobu designed many of these. No. 17 is another example.

This print is one of Harunobu's most esteemed designs and a perfect illustration of the extent to which the development of full-color printing made possible a new subtlety in the rendering of atmosphere and mood.

Former Collection: Haviland
Reproduced: Haviland Sale Catalogue, June 1923, No. 80; Ledoux, *Harunobu and Shunshô,* No. 19; Hillier, *Gale Catalogue,* No. 64

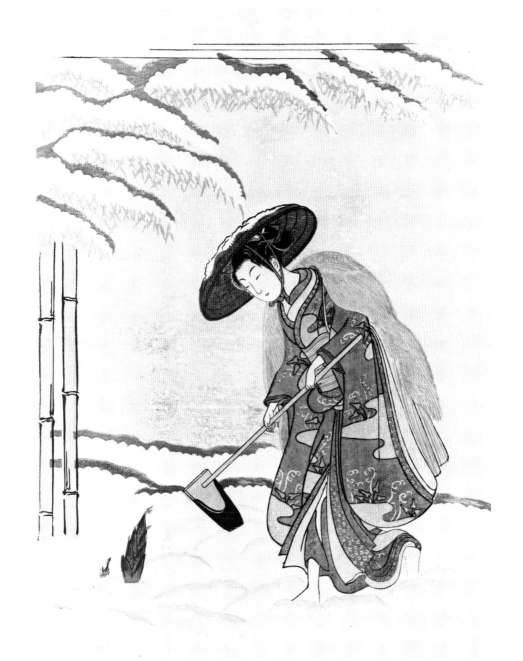

71

22 Suzuki Harunobu
LOVERS AND MANDARIN DUCKS IN THE SNOW

chûban, 11¼ x 8½ inches (28.5 x 21.6 cm.)
Signature: Harunobu ga
Date: ca. 1768
Mr. and Mrs. John R. Gaines

A pair of lovers, sharing an umbrella, stand in the snow, looking at a pair of mandarin ducks sitting on a nearby bank. The dark gray sky is thick with large, wet snowflakes, and a second pair of ducks swim in the water; but otherwise nothing disturbs the muffled quiet of the scene. The girl slips her hand under the young man's sash in a delicate gesture that expresses the couple's intimacy. In the Orient, mandarin ducks are regarded as emblems of conjugal fidelity, and this meaning is underlined by the poem written in the cloud form overhead: *Tsurakaraji/Urayamashiku mo/Oshidori no/Hane o kawaseru/Chigiri nariseba*, "Since ours is the enviable love of mandarin ducks, pledged with crossed wings, we should not be sad."

Reproduced: Noguchi, *Harunobu*, Pl. 67; Ledoux, *Harunobu and Shunshô*, No. 22; Hillier, *Harunobu Catalogue*, No. 104; Popper Sale Catalogue, No. 53; Narazaki, *Zaigai Hihô, Harunobu*, No. 55

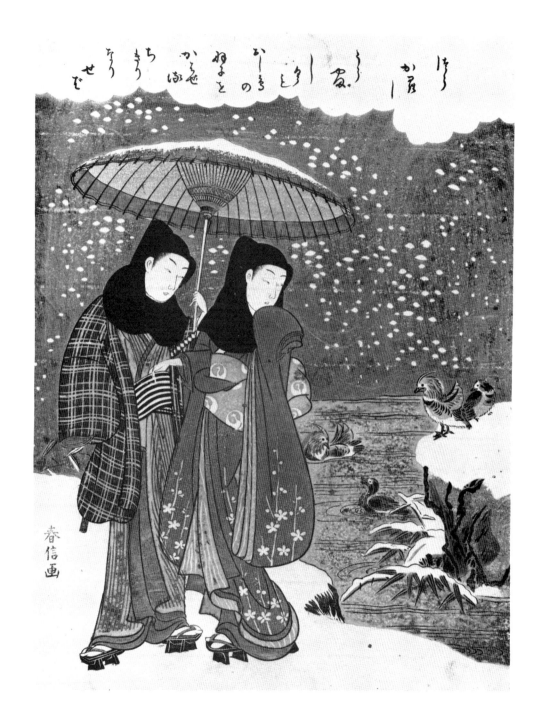

23 Suzuki Harunobu
WOMAN ON A VERANDAH
chûban, 10⅝ x 8 inches (27 x 20.3 cm.)
Signature: Suzuki Harunobu ga
Date: ca. 1767
Ruth Stephan Franklin

The young woman has just emerged from her bath and is still drawing her loose, striped *yukata* about her as she steps to the edge of the verandah. A faint breeze stirs the wind chime above her. A pot of pinks, *nadeshiko,* is placed at the corner of the verandah and a few steps away is a stream or pond with iris growing along the banks. This is Harunobu at his best; with a minimum of means he evokes the atmosphere of a season, of a time of day even, and invites us to share the sense of refreshment the woman herself seems to feel. There is not a single element in this design that is not absolutely essential to it, and part of our enjoyment of the picture undoubtedly stems from this sense of its esthetic purity.

This print, representing "summer," was brought out along with three other designs, two of them reissues from the famous *Zashiki Hakkei* series, as a set entitled *Shinpan Fûryû Shiki no Hana,* or "A New Printing: Elegant Flowers of the Four Seasons." The complete set, along with its original wrapper, is still to be found together in a private Japanese collection.

Reproduced: Ledoux, *Harunobu and Shunshô,* No. 28

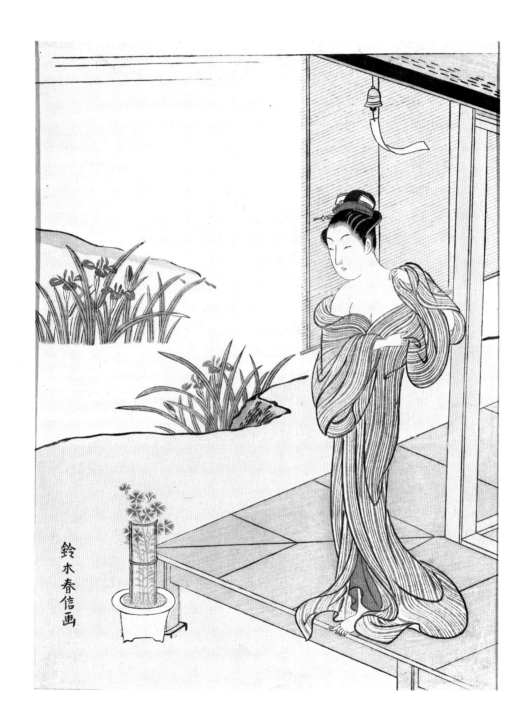

鈴木春信画

75

24 **Attributed to Suzuki Harunobu**
A YOUNG WOMAN CROSSING A SNOW-COVERED BRIDGE

chūban, 10¾ x 8 inches (27.3 x 20.3 cm.)
No Signature; Illegible Seal, probably of the person who commissioned the print
Date: 1765
Mr. and Mrs. Richard Gale

The touching frailty and vulnerability that one senses in so many of Harunobu's figures is even more apparent than usual in this picture of a girl crossing a snow-covered bridge. The landscape is featureless, except for the river, and the girl is alone. She shields herself from the wind and snow by holding one of her long sleeves over her head while with her other hand she holds up the excess length of her kimono. Where is she going, one wonders, this "frail little lady with the forces of Nature strong about her?" We will never know. Yet even if its ultimate significance escapes us, there remains something curiously compelling about this image. Can it be that it symbolizes all imperiled crossings from one unknown to another?

Since this is another of those calendar prints made for private distribution among small circles of literary *amateurs*, whoever commissioned the print probably had some specific reference in mind. Ledoux suggested the subject known as *Sano no Watari*, "The Crossing at Sano," traditionally represented in art by a nobleman riding through a snowstorm, his right sleeve raised to protect his head from the falling flakes.

Calendar marks appear between the ends of the timbers forming the floor of the bridge.

This print came directly to Ledoux from his friend, Raymond Koechlin. It meant so much to him, for itself and for its associations with Koechlin, that he once wrote, "May he or she into whose keeping it passes from mine find it like firelight in a winter room."

Reproduced: Vignier and Inada, *Harunobu, Koriusai, Shunshô*, No.36; Von Seidlitz, *Les Estampes Japonaises*, Pl. 22; Ledoux, *Harunobu and Shunshô*, No. 33; Hillier, *Gale Catalogue*, No. 63

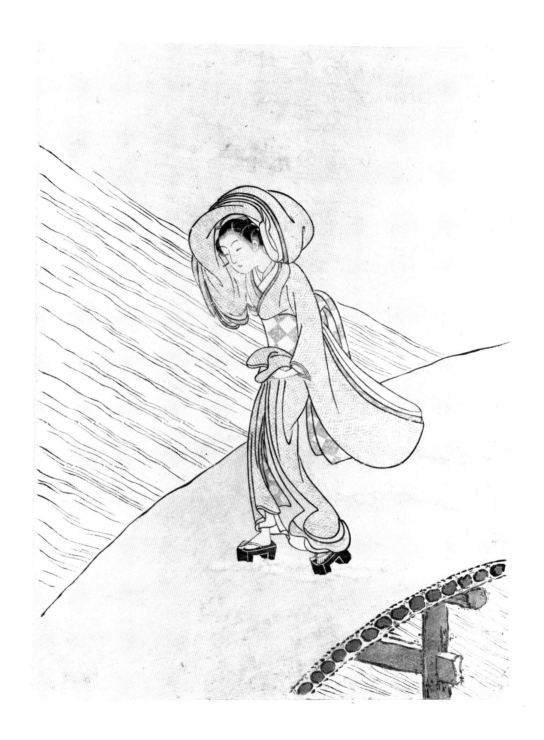

77

25 Katsukawa Shunshô
TWO SUMÔ WRESTLERS: NIJI-GA-TAKE SOMAEMON (right) and
FUDE-NO-UMI KIN'EMON (left)
ôban, 15 x 10 inches (38.1 x 25.4 cm.)
Signature: Shunshô ga
Publisher's Seal: Matsu
Date: ca. 1772
The Art Institute of Chicago, Clarence Buckingham Collection

Here Shunshô applies to a pair of *sumô* wrestlers the same realism he had
brought earlier to his portrayals of *kabuki* actors. Note how he picks up details
like the cauliflower ears, the flattened nose, and marked stoop of the wrestler
at right. He emphasizes the enormous bulk of the two men by drawing them
so that they barely seem to fit within the confines of the paper. The lighter
colors in this print have oxidized in such a way as to show the marks left by
the baren as it moved in different directions pressing the paper into contact
with the block.

Former Collection: Jacquin
Reproduced: Jacquin Sale Catalogue, No. 87; Ledoux, *Harunobu and Shun-
shô*, No. 34; Stern, *Master Prints of Japan*, No. 69

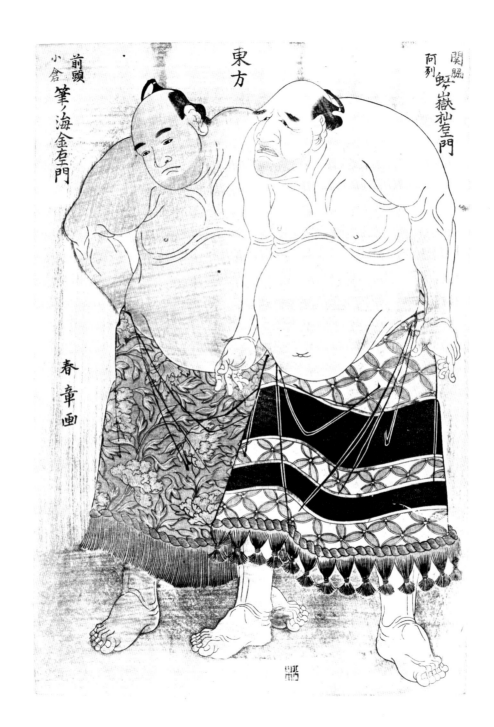

26 Katsukawa Shunshô
BANDÔ MATATARÔ AS GEMPACHIBYÔE

hosoban, 11⅞ x 5½ inches (30.2 x 14 cm.)
Artist's Seal: Hayashi
Date: 1769
Mr. and Mrs. Richard Gale

In this early work by Shunshô, Matatarô looks for all the world like a puppet dangling from a string as he gesticulates in mock rage in front of an indifferentiated dark gray background. He wears a harlequin-like costume and recites the lines written in reserve above him. The plain background, providing no clues as to setting, is typical of Shunshô's early actor prints, but here the "cut out" look this gives the figure is particularly effective as a means of indicating the comic nature of the role.

Reproduced: *Grolier Figure Print Catalogue,* Pl. XIII; Ledoux, *Harunobu and Shunshô,* No. 36; Hillier, *Gale Catalogue,* No. 102

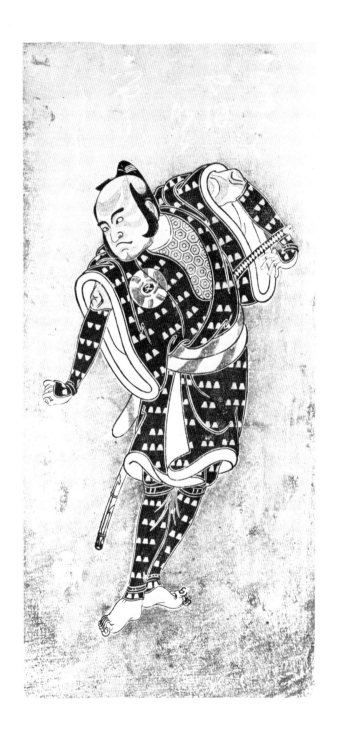

27 Katsukawa Shunshô
ÔTANI HIROEMON IV AS A HIGHWAYMAN

hosoban, 12⅞ x 5½ inches (32.7 x 14 cm.)
Signature: Shunshô ga
Date: 1777
Mr. and Mrs. Richard Gale

Shunshô has captured Hiroemon at an intensely dramatic moment, as, a terrific scowl distorting his features, he clutches at his sword with one hand while brandishing a lantern with the other. This print, like most of Shunshô's *hosoban*, was probably designed to form part of a triptych. It seems to have lost nothing, however—indeed perhaps it has gained—by being isolated.

For Ledoux, prints like this, depicting "one of those tense moments of the *kabuki* stage when violent mental action is co-ordinated with readiness for violent physical action, and the stress of mind and body are expressed together in a pose or gesture of dramatic intensity," represented Shunshô at his best.

Reproduced: Ledoux, *Harunobu and Shunshô,* No. 40; Gentles, *Masters of the Japanese Print,* No. 61; Hillier, *Gale Catalogue,* No. 108

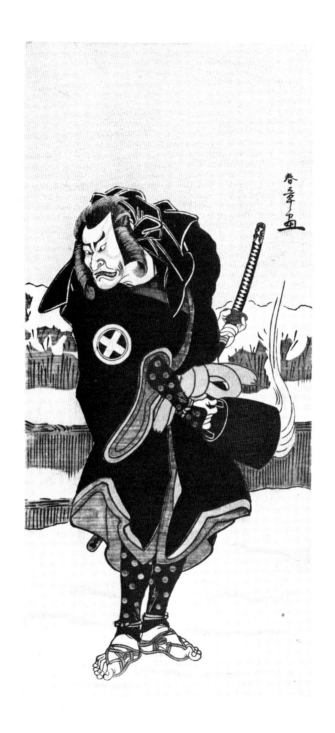

83

28 Katsukawa Shunshô

"THE RED DANJÛRÔ," ICHIKAWA DANJÛRÔ V IN A SHIBARAKU ROLE

hosoban, 12 x 5½ inches (30.5 x 14 cm.)
Signature: Shunshô ga
Date: 1779
Mr. Thomas J. Rosenberg

Hunched over, his robes drawn about him so that only his face and the top of his head emerge from them, the great Danjûrô stalks down the stage. The profile view is unusual in depictions of this famous role. Here the angular garments fall into place in such a way as to repeat the shape of the *mon* of the theater emblazoned on the curtain behind. It is indeed, as Ledoux said, "a daring and impressive design."

Ledoux's discussion of the role and its history is too succinct and informative not to repeat: "To appear in Shibaraku was the exclusive privilege of the leading actors of the Ichikawa line, and they inserted the act only in the 'face-viewing performance' with which the theatrical season opened each year. At some time during these introductory performances the highest ranking Ichikawa, most frequently Danjûrô, was accustomed to come posturing down the 'flower-walk' and call out 'Shibaraku!' 'Wait a moment!' so impressively that the villain on the stage stopped trying to murder the hero until the interpolated act was ended. The plot and name of the interlude might vary from year to year but the habit of having such an episode remained. In *Shibaraku*, Danjûrô usually impersonated a great noble, and each head of the Ichikawa family from the second, who originated the custom in 1714, wore for this role an enormous sword and an enveloping outer garment of heavy material which generally, if not always, was of a red-brown hue and bore the Ichikawa *mon* of three concentric squares in white."

Reproduced: Ledoux, *Harunobu and Shunshô*, No. 41

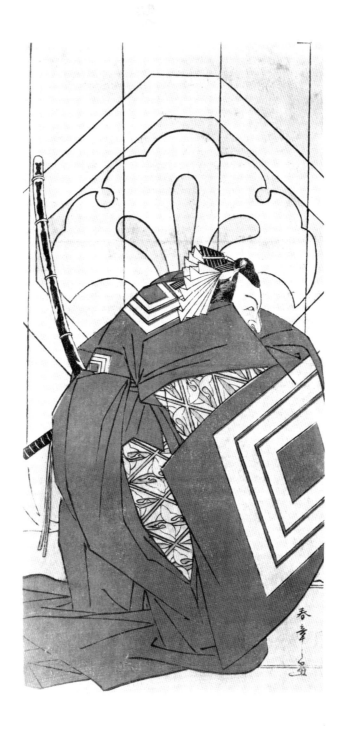

29 Katsukawa Shunshô
"THE BLACK DANJÛRÔ," DANJÛRÔ V AS SAKATA NO KINTOKI
hosoban, 12½ x 6 inches (31.7 x 15.2 cm.)
Signature: Shunshô ga
Date: 1781
The Art Institute of Chicago, Clarence Buckingham Collection

How different this print is from No. 27. There the intense drama of the scene grows out of the story line of the play; the personality of the actor disappears and we accept him in his assumed role. In the same way, we take the snow-covered fence and ground as belonging not so much to the stage as to the real world. Here we are not expected for a moment to forget that it is theater we see or that it is the great Danjûrô himself who scowls out at us from behind the flat planes of his voluminous black robes. Spectacle and brilliance of staging have always been important in *kabuki.* Here they are the very substance of the scene depicted.

Reproduced: *Shibai Nishiki Shûsei,* No. 170; U.T., Vol. V, No. 133; Ledoux, *Harunobu and Shunshô,* No. 46; Gentles, *Masters of the Japanese Print,* No. 65

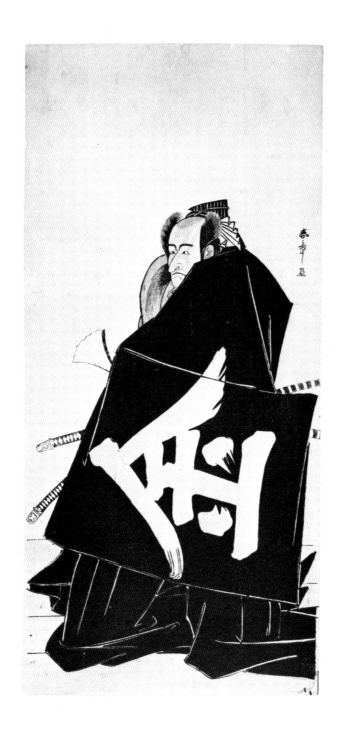

87

30 Attributed to Ippitsusai Bunchô
CHRYSANTHEMUMS AND PINKS IN A VASE

hosoban, 13 x 6 inches (33 x 15.2 cm.)
No Signature
Date: ca. 1770
The Art Institute of Chicago, Clarence Buckingham Collection

There is something curiously unpretentious and appealing about this jar of flowers. The blue background, the embossing, and the simplicity of the design all point to a date somewhere between 1766 and the early 1770's; that is, to the earliest phase of the full-color print. Harunobu and Koryûsai also designed flower prints at that time, but the drawing and palette in this case definitely suggest Bunchô. The print is rare, possibly even unique.

Reproduced: Noguchi, *Harunobu* (1932), Pl. 36; Ledoux, *An Essay on Japanese Prints*, Pl. VII; Ledoux, *Bunchô to Utamaro*, No. 9

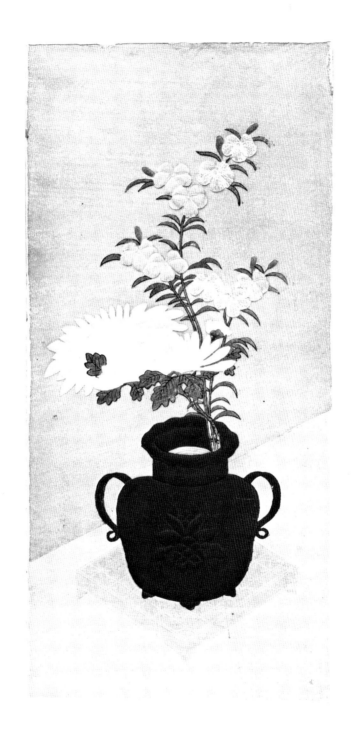

31 Isoda Koryûsai
THE FAMOUS COURTESAN HANA-ÔGI WITH ONE OF HER GIRL ATTENDANTS

from the series: *Azuma Ogi*, "Fans of the East (i.e. Edo)," printed on an *ôban* sheet, 17⅞ x 12⅞ inches (45.4 x 32.7 cm.), but size of fan alone 20½ x 7¾ inches (52 x 19.7 cm.)
Signature: Koryûsai zu, with *kakihan*
Publisher: Iwatoya Gempachi
Date: ca. 1778
The Art Institute of Chicago, Clarence Buckingham Collection

The fan print is as difficult a format as the *hashira-e*. Koryûsai was a master at both. His design here is particularly ingenious. There is something tantalizing in the way the richly clad Hana-ôgi is poised at the very edge of the picture, about to move out of it but held back for a moment by her curiosity in something happening outside the picture to the right. The elegant curve of her pose repeats the curve of the fan itself, while the more vertical form of her attendant gives the design its necessary stability.

The fan is printed diagonally on a standard *ôban* sheet of paper. The series title, the name of the publisher, and directions for mounting the fan are printed on the same sheet. The directions make it clear that—difficult as it is to believe—designs like this were actually made to be cut out and pasted on wooden ribs to be used as fans.

Shunshô also designed prints for this series.

Reproduced: Ledoux, *Bunchô to Utamaro*, No. 16; Gentles, AIC II, Koryûsai, No. 177

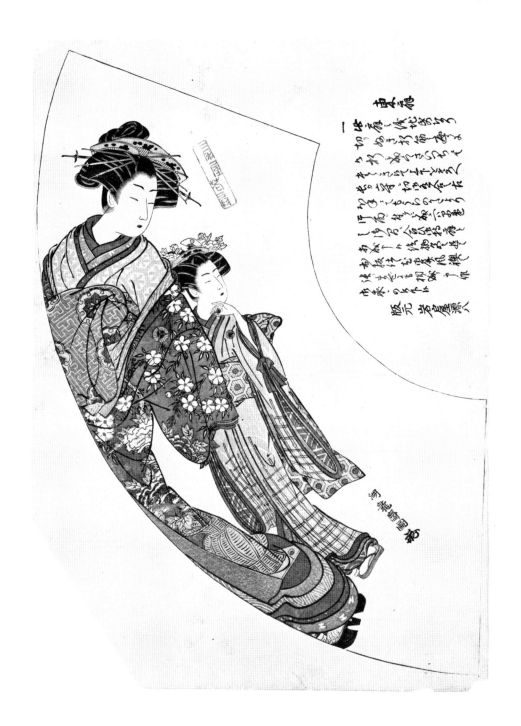

32 Isoda Koryûsai

A LONG-TAILED BIRD ON A FLOWERING PLUM BRANCH

from the series: *Azuma Ôgi*, "Fans of the East (i.e. Edo)," printed on an *ôban* sheet, 18¼ x 12¹⁵/₁₆ inches (46.4 x 33 cm.), but size of fan alone 7¾ x 20½ inches (19.7 x 52.0 cm.)
Signature: Koryû ga, with *kakihan*
Publisher: Iwatoya Gempachi
Date: ca. 1778
The Toledo Museum of Art, Toledo, Ohio

This print is from the same series as the last, but the subject is a more conventional one for the format. The design is based on Chinese prototypes, perhaps on some of the illustrations in *The Mustard Seed Garden Manual,* which was already well-known in Japan by this time.

Reproduced: Ledoux, *"Bunchô to Utamaro,"* No. 17

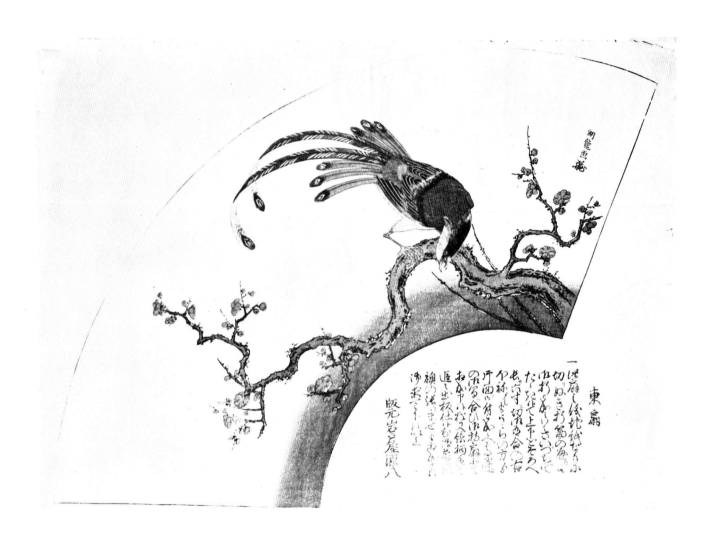

33 **Torii Kiyonaga**
THREE FIGURES

from the series: *Tôsei Yûri Bijin Awase,* "A Set of Beauties of the Licensed Quarters," *ôban,* 14⅞ x 10 inches (37.8 x 25.4 cm.)
Signature: Kiyonaga ga
Date: 1784
The Toledo Museum of Art, Toledo, Ohio

There is a stability, a firmness of structure, to Kiyonaga's compositions that can be extremely satisfying but that leaves little room for the unexpected. Kiyonaga is never extravagant, and in that respect he is the very opposite of Utamaro, whom Ledoux obviously preferred. Even in this print a certain matter-of-factness, a certain lack of excitement, is evident; and yet, one must admit, the composition is superb. The woman standing at the right is particularly lovely. Kiyonaga often used such tall, column-like beauties to emphasize (and anchor) the vertical elements in his designs, playing these off against seated or reclining figures, as here, or objects, such as the *tabako-bon* and sake pot, strewn across the floor, The result was invariably a well-considered, well-constructed composition of considerable, even if of restrained, beauty.

Reproduced: Ledoux, *Bunchô to Utamaro,* No. 21

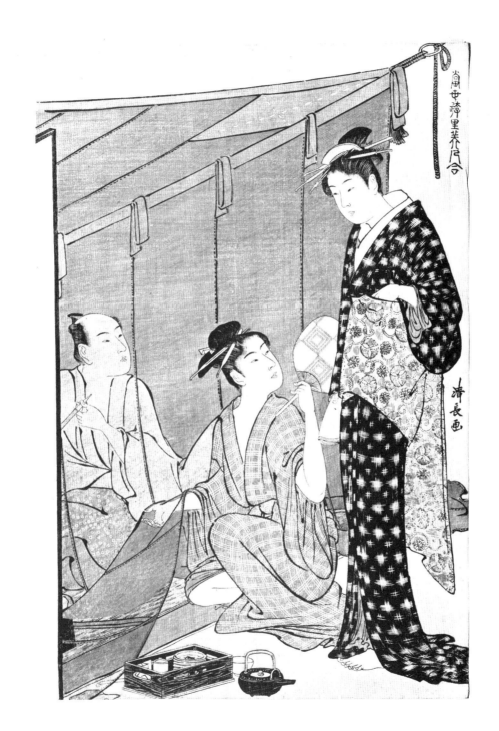

95

34 Torii Kiyonaga
THE PRINCESS ISE AND A GIRL ATTENDANT

ôban, 14⅞ x 9¾ inches (35.3 x 24.8 cm.)
Signature: Kiyonaga ga
Date: ca. 1784
The Art Institute of Chicago, Clarence Buckingham Collection

This print belongs to a series that stands somewhat apart from the bulk of Kiyonaga's work. As mentioned earlier, however, Ledoux was never overly fond of Kiyonaga's more typical designs and apparently found subjects like this much more to his liking. The series is untitled but the subjects are all court ladies of the past well known in Japanese literature, and each print refers, even if only obliquely, to some poem from one of the classical anthologies. Here the reference is thought to be to a *waka* by Princess Ise (flourished ca. 935): *Haru kasumi/Tatsu o misutete/Yuku kari wa/Hana naki sato ni/Sumi ya naraeru,* "Departing geese, forsaking the rising mists of spring, what will they think of a village without cherry blossoms?" Ledoux wrote of the stateliness and dignity of this composition, "with its diagonal sweep from left to right perfectly balanced and held within the composition." The contrast between the sumptuous court robes of the figures and the soft spring haze in the background is no less remarkable.

Reproduced: Ledoux, *An Essay on Japanese Prints,* Pl. VIII; Ledoux, *Bunchô to Utamaro,* No. 22; Gentles, *Masters of the Japanese Print,* No. 72

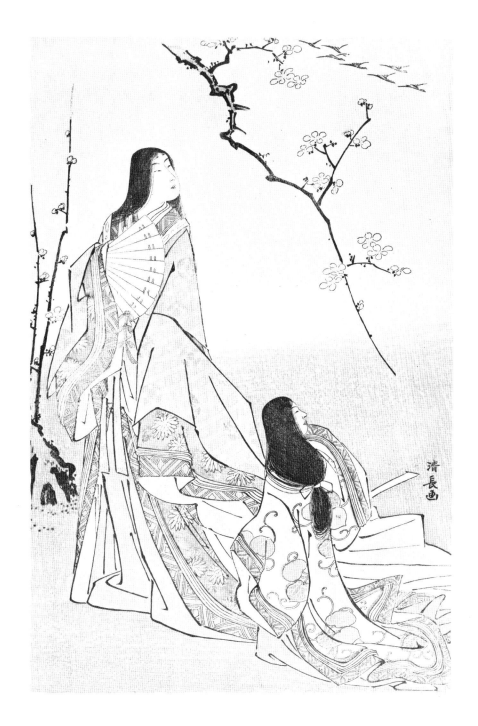

35a-f
Kubo Shunman
MU TAMAGAWA, "THE SIX CRYSTAL RIVERS"

ôban hexaptych, average size of each sheet: 14½ x 9⅞ inches (36.8 x 25.1 cm.)
Signature: Shunman ga; except a, which is signed Kubo Shunman ga, b, which bears no signature, and f, which is sealed but not signed
Publisher: Fushimiya Zenroku
Date: ca. 1787
Mr. and Mrs. Richard Gale

There are certain *ukiyo-e* artists whose work, though it never gained the currency attained by the prints of their better known contemporaries, is marked by a distinction that places it among the greatest masterpieces of the school. Chôki is one of these; Shunman is another. And though Chôki obviously came under the influence of Utamaro, just as Shunman obviously came under the influence of Kiyonaga, the work of both men remains highly individual.

The theme of the Six Crystal Rivers was a familiar one in *ukiyo-e;* but always before it had been treated in serial fashion, never combined, as here, into a single continuous composition. Traditionally, specific associations are linked with each of the six rivers, plovers with the river at Noda, for instance, and *hagi,* "bush clover," with the river at Noji. Shunman has worked all of these traditional associations into his composition; and though the six rivers have become one, the weather and even the seasons change from print to print. The landscape elements—appropriately enough, considering the theme—are more important here than in other figure prints of the period and are responsible for much of the sense of vitality that distinguishes the work. The color too is remarkable, restricted as it is to black and tones of grey except for an occasional touch of green, pink, yellow, or bright red. Only Shunchô, among *ukiyo-e* artists, used a similar palette.

This hexaptych is extremely rare in the original edition of 1787. A second edition was brought out a few years later by the publisher Tsutaya, but the colors were much stronger and the total effect was quite different.

Former Collection: Garland
Reproduced: Garland Catalogue, No. 101 (print E only); Ledoux, *Bunchô to Utamaro,* No. 26 A-F; Hillier, *Gale Catalogue,* No. 133 A-F

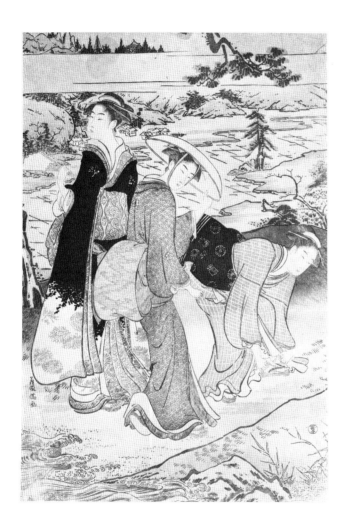

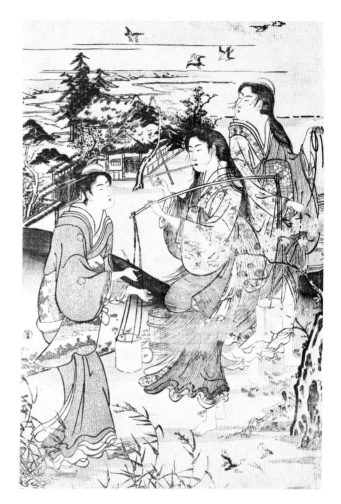

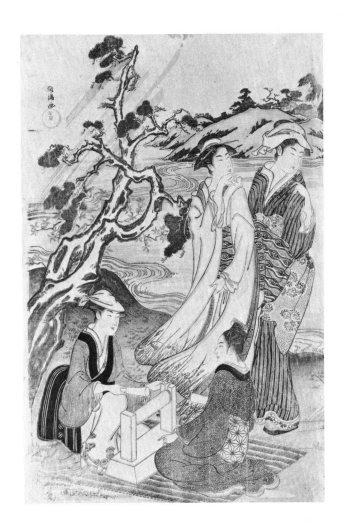

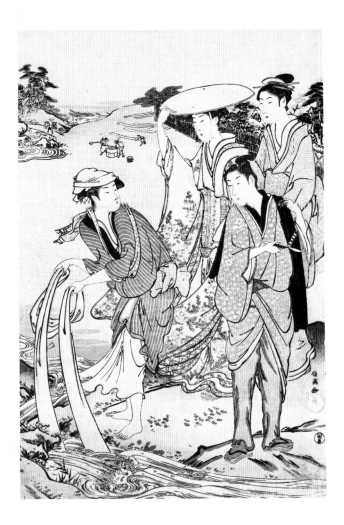

100

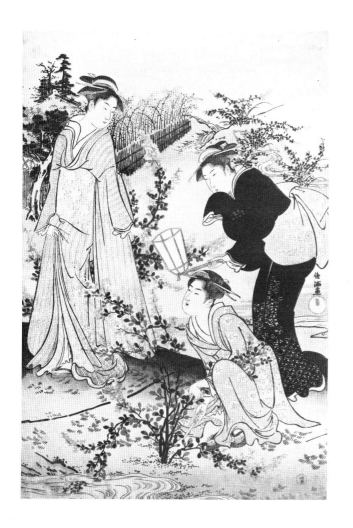

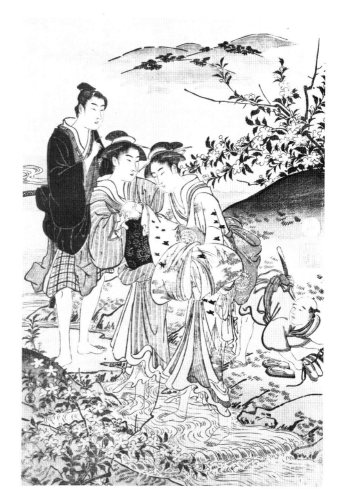

101

36 **Kitagawa Utamaro**
A YOUNG MAN SHAVING THE NECK OF A SEATED WOMAN

from the series: *Fûryû Goyô no Matsu,* "Elegant Five Needle Pines," *ôban,*
15¼ x 10⅛ inches (38.7 x 25.7 cm.)
Signature: Utamaro hitsu
Publisher: Tsuruya
Date: ca. 1795
Prints Division, The New York Public Library, Astor, Lenox, and Tilden
Foundation

Ledoux identified these two figures as the lovers Saizô and O-Koma, but on
what basis is unclear. Each of the five prints in this series shows a man and a
woman together, and it may well be that pairs of lovers were intended. So-
called "hair dressing" scenes were popular from an early time in *kabuki*
(hence also in *ukiyo-e),* where they symbolized deep affection between two
people. Perhaps such implications are present here too. In any case, the design
is an appealing one, with its fluent, cascading lines, and shows none of that
straining for effect so noticeable in some of Utamaro's two-figure composi-
tions. The color is unusually well preserved.

Former Collection: Frank Lloyd Wright
Reproduced: Ledoux, *Bunchô to Utamaro,* No. 33

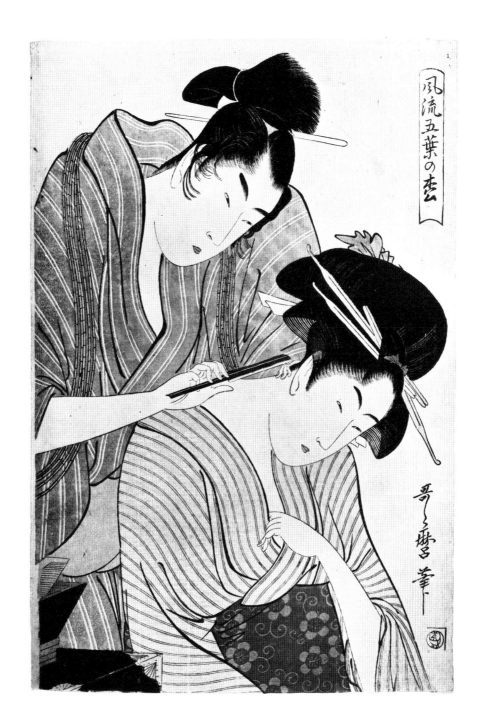

風流五葉の松

哥△麿筆

103

37 **Kitagawa Utamaro**
WOMAN DRYING HER CHEEK, OR "NAN-EKI, A BEAUTY OF THE SOUTHERN QUARTER (SHINAGAWA)"
ôban, 15 x 10 inches (38.1 x 25.4 cm.)
Signature: Utamaro hitsu; Collector's Seal: Burondo (Blondeau)
Publisher: Tsuruya
Date: ca. 1796
Prints Division, The New York Public Library, Astor, Lenox, and Tilden Foundation

Perhaps nowhere is Utamaro's genius more evident than in prints of such deceptive simplicity as this, where everything depends upon absolute perfection of placement. The partially-clad female form often seems awkward when treated by other *ukiyo-e* artists, whose forte was in the complex orchestration of rich fabrics; this never, or rarely, seems to be the case with Utamaro. If one were to ask why, surely the answer would have something to do with his handling of line. No other *ukiyo-e* artist drew with such seeming effortlessness; no other could express volume with such certainty or with anything like the same economy of means.

Former Collections: Blondeau, Haviland, Garland
Reproduced: Ledoux, *An Essay on Japanese Prints*, Pl. III; Ledoux, *Bunchô to Utamaro*, No. 38; Hillier, *Utamaro: Colour Prints and Paintings*, No. 74

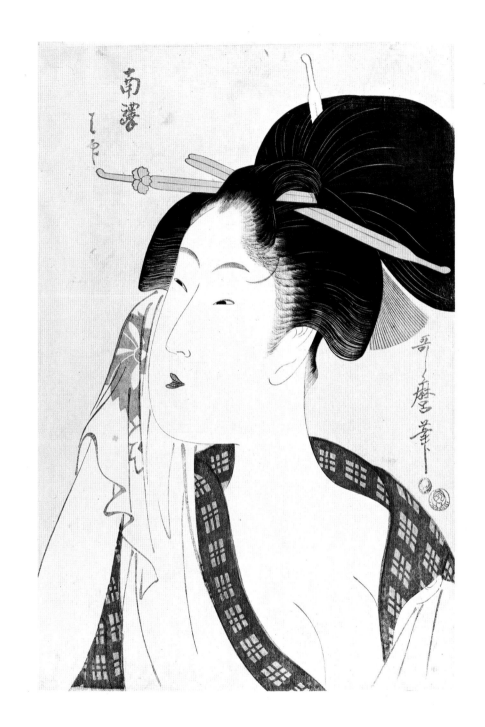

38 Kitagawa Utamaro
SEIRÔ SAN BIJIN, "THREE BEAUTIES OF THE GREEN HOUSES"
ôban, 14¾ x 9¾ inches (37.4 x 24.7 cm.)
Signature: Utamaro hitsu; *kiwame* seal
Collector's Seal: Hayashi
Publisher: Tsuruya
Date: ca. 1793
Private Collection

An impressive design, more formal in effect than the nearly contemporary mica-ground bust portraits of single figures (such as Nos. 39 or 40). The tall beauty in the center with her "butterfly" hair-do dominates the composition. She is a courtesan and is dressed in all the finery associated with her calling. Her two companions, however, seem to be *geisha*, probably attached to the same house. They are about to take part in a *niwaka* performance and are masquerading as *chasen-uri*, "tea-whisk vendors." This was a type of peddler actually known only in the Kansai area and never seen in Edo. One of the girls carries a bamboo pole festooned with tea whisks; the other beats a gourd with a stick. *Niwaka* performances were annual events in the Yoshiwara. They took place at the start of the eighth month of the old lunar calendar—in other words, in late September or early October—and involved dances and processions as well as more formalized plays. A carnival-like atmosphere must have pervaded the Pleasure Quarters during the season when these performances were held.

A second *kiwame* seal and another publisher's mark are just visible at the edge of the print at the lower right. They were apparently part of the key block impression, but were covered by the mica, necessitating a second overprinting of the same seals. *Mon* can just be made out on the sleeves of the two *geisha*. The kimono, now faded, were originally blue, against which the *mon*, appearing in relief, would have stood out clearly.

Reproduced: Ledoux, *Bunchô to Utamaro*, No. 42

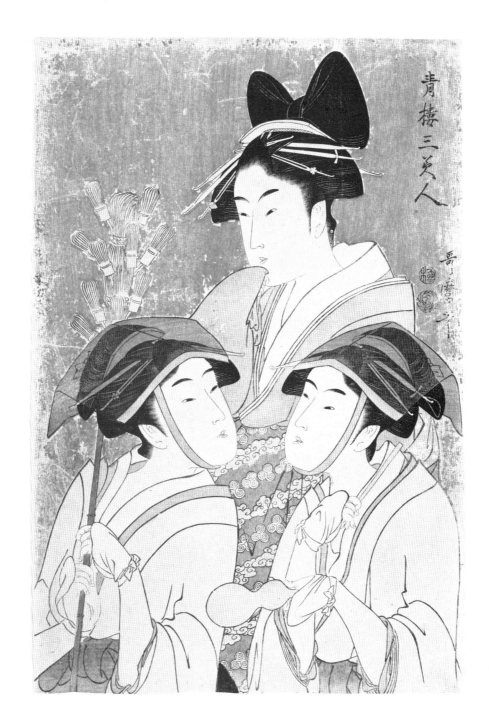

107

39 Kitagawa Utamaro
THE WAITRESS O-KITA OF THE NANIWA TEAHOUSE

ôban, 14¾ x 9⅜ inches (37.4 x 23.8 cm.)
Signature: Utamaro hitsu; *kiwame* seal
Publisher: Tsutaya
Date: 1792-93
Mr. and Mrs. Richard Gale

There are those who believe that this and a handful of other half-length portraits (such as No. 40), all with mica backgrounds and apparently all designed at about the same time, represent Utamaro at his most perfect, before any signs of "decadence" had set in. Without question there is a refinement to these prints, a delicacy of treatment, that is missing in Utamaro's later work. That refinement is particularly evident here, perhaps because Utamaro purposely keeps us somewhat distant from his subject. There is something extremely appealing about the young waitress intent on carrying her tray; she moves ahead completely unaware that she is being observed. From the standpoint of technique this print is quite remarkable too. One cannot help but admire craftsmanship capable of reproducing both the stiff, lacquer-like perfection of the girl's coiffure and, at the same time, the soft, loose texture of her gown.

Former Collection: Mutiaux
Reproduced: Mutiaux Sale Catalogue, No. 250; Ledoux, *Bunchô to Utamaro*, No. 44; Hillier, *Gale Catalogue,* No. 146

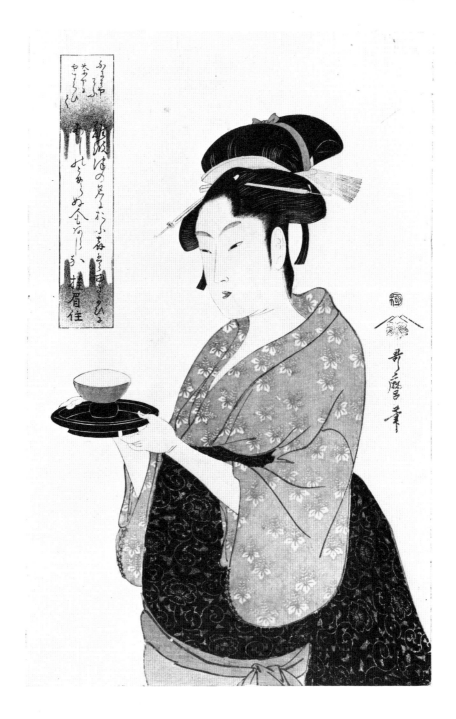

109

40 Kitagawa Utamaro
THE "FICKLE TYPE"

from the series, *Fujin Sôgaku Juttai,* "Studies of Ten Kinds of Female Phy-
siognomy," *ôban,* 14¼ x 10 inches (36.2 x 25.4 cm.)
Signature: Sômi (physiognomist) Utamaro ga; *kiwame* seal
Publisher: Tsutaya Jùsaburô
Date: ca. 1794
Miss Edith Ehrman, New York

A lovely print and one of Utamaro's masterpieces, combining the utmost
suavity of line with the delicacy and restraint that still characterized his work
at this period. The three-panelled cartouche at the upper left bears the series
title in the right-hand column and the artist's signature, the *kiwame* seal, and
the publisher's mark in the left, while the center panel remains blank. In some
impressions the center panel bears the inscription, *uwaki no sô,* the "fickle
(sometimes also translated as 'passionate') type." Such designations, how-
ever, seem to be purely fanciful; at least for a Westerner, and at this distance
in time, it is difficult to discern in this picture any clear indication of the lady's
temperament.

Former Collection: M. Chavarse
Reproduced: Chavarse Sale Catalogue, No. 79; Ledoux, *Bunchô to Utamaro,*
No. 48

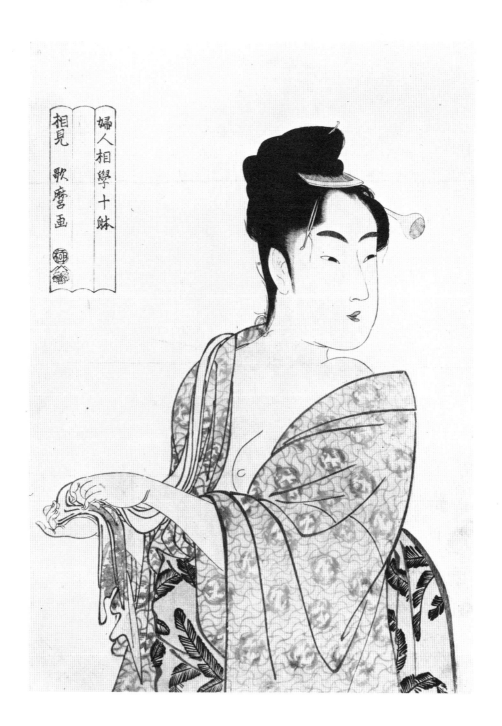

婦人相學十躰
相見　歌麿画

111

41 **Tôshûsai Sharaku**
SEGAWA KIKUNOJÔ III AS THE DANCER HISAKATA POSING AS THE NEW YEARS DANCER YAMATO MANZAI

hosoban, 12¼ x 5¾ inches (31.1 x 14.6 cm.)
Signature: Sharaku ga; *kiwame* seal
Publisher: Tsutaya
Date: 1794
The Metropolitan Museum of Art, Harris Brisbane Dick Fund, 1949

Kikunojô's bearing is particularly regal and impressive in this small print, and though playing a woman's part (he was a famous *onnagata),* he seems—in this depiction at least—essentially masculine. This print is one of the most famous of Sharaku's *hosoban* designs. Ledoux considered it "a superb thing in composition, dramatic power and characterization."

Reproduced: Henderson and Ledoux, No. 129; Ledoux, *Sharaku to Toyokuni,* No. 10; Gentles, *Masters of the Japanese Print,* No. 85

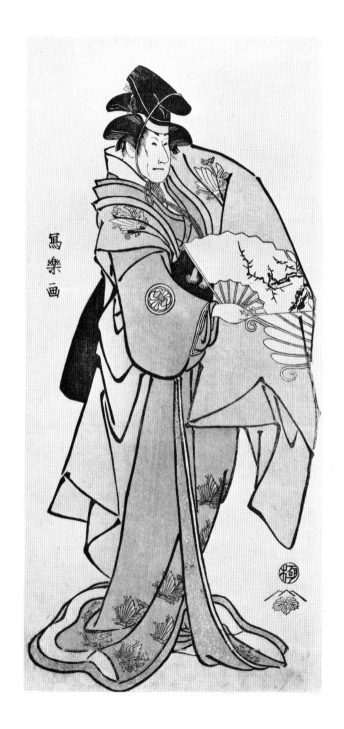

写楽画

113

42 Tôshûsai Sharaku
BANDÔ MITSUGORÔ II AS ISHII GENZÔ

ôban, 15 x 10 inches (38.1 x 25.4 cm.)
Signature: Tôshûsai Sharaku ga; *kiwame* seal
Publisher: Tsutaya
Date: 1794
The Metropolitan Museum of Art, Harris Brisbane Dick Fund, 1949

This is one of the rarest and most dramatic of Sharaku's bust portraits on dark mica grounds. The actor, his head thrust forward, a ferocious scowl on his lips, is shown in the very act of drawing his sword. The scene depicted was a particularly climatic one. Ishii is attempting to strike down an enemy but will, in a moment, meet death himself. Color plays a relatively minor part in this print, much of the figure's costume being rendered in gauffrage. As a result, nothing detracts from the lines, which seem to be charged with a dramatic intensity of their own.

Reproduced: Ledoux, *Sharaku to Toyokuni,* No. 14

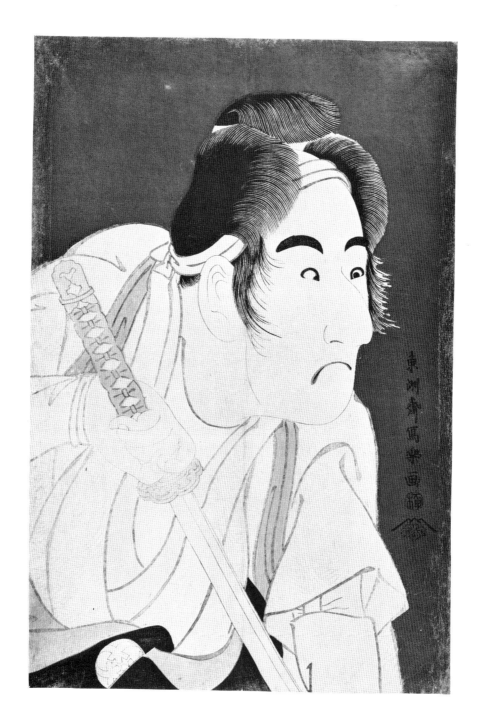

Tôshûsai Sharaku

43 **THE PROGRAM ANNOUNCER SHINOZUKA URAEMON OF THE MIYAKO-ZA THEATER**

ôban, 14⅜ x 10 inches, (36.5 x 25.4 cm.)
Signature: Tôshûsai Sharaku ga; *kiwame* seal
Publisher: Tsutaya
Date: 1794
The Metropolitan Museum of Art, Harris Brisbane Dick Fund, 1949

Whether the figure represented here is the theater director Miyako Dennai III, as Ledoux and others thought, or whether it is the program announcer of the Miyako-za, as more recent research seems to suggest, in no way affects its status as one of Sharaku's most masterful characterizations. The face, with its baggy cheeks, many fine wrinkles, and tiny, squinting eyes, is fascinating and contrasts interestingly with the simple, massive bulk of the body.

Former Collection: Ficke
Reproduced: Ficke Sales Catalogue, No. 186; Henderson and Ledoux, No. 1; Inouye, *Sharaku,* page 1; Fujikake, *Ukiyo-e no Kenkyû,* No. 275; Ledoux, *Sharaku to Toyokuni,* No. 17; Gentles, *Masters of the Japanese Print,* No. 77; Suzuki, *Sharaku,* No. 1; Stern, *Master Prints of Japan,* No. 122

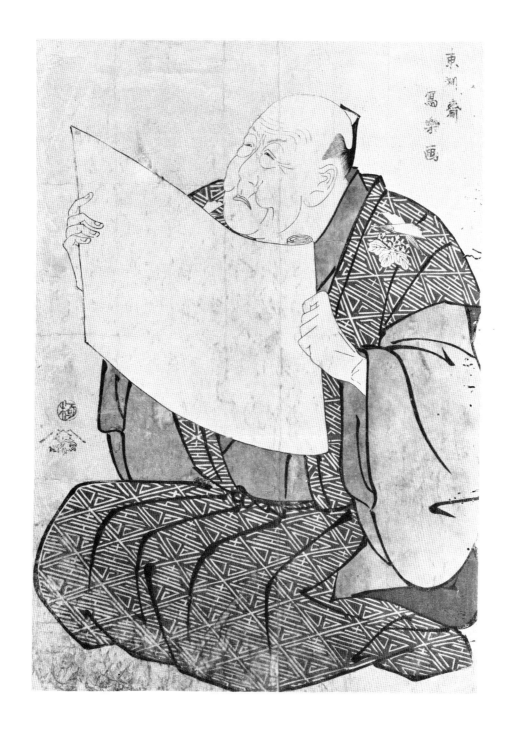

東洲斎
写楽画

117

44 Tôshûsai Sharaku

BUST PORTRAIT OF SEGAWA TOMISABURÔ II AS YADORIGI, THE WIFE OF ÔGISHI KURANDO

ôban, 14⅝ x 9⅞ inches (37.1 x 25.1 cm.)
Signature: Tôshùsai Sharaku ga; *kiwame* seal
Publisher: Tsutaya
Date: 1794
The Metropolitan Museum of Art, Harris Brisbane Dick Fund, 1949

Most earlier *ukiyo-e* artists attempted to make *onnagata* (actors specializing in women's roles) look as feminine as possible. Sharaku broke with this tradition. Here, by emphasizing a few subtle details, like the strength of Tomisaburô's upraised hand or the heaviness of his jawbone, he breaks through the illusion the actor had attempted to create with his elaborate coiffure, his make-up, his elegant robes and his mincing demeanor. As Harold P. Stern has said, "those portrayed by Sharaku must have grimaced when they saw themselves revealed in the harsh light of his mirror."

The large characters to the left of Sharaku's signature are brush written and give the actor's name.

Reproduced: Ledoux, *Sharaku to Toyokuni,* No. 19

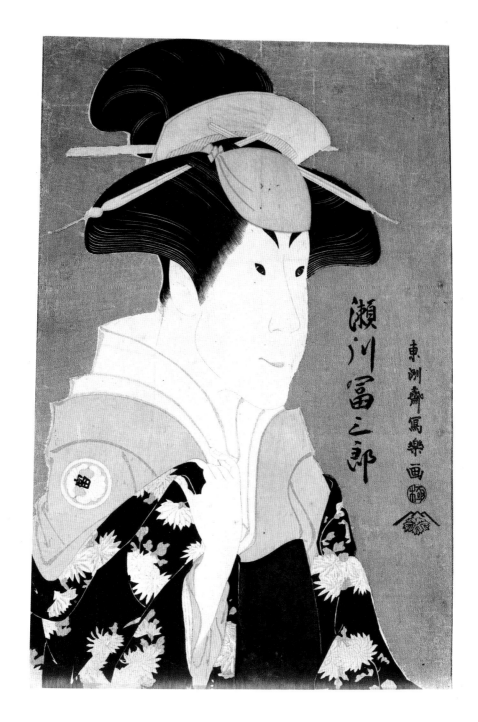

45 Tôshûsai Sharaku
NAKAMURA KONOZÔ AS GON OF THE KANAGAWAYA BOATHOUSE AND NAKAJIMA WADAEMON AS BÔDARA NO CHÔZAEMON (CHÔZAEMON THE "DRIED CODFISH")

ôban, 15⅛ x 10⅛ inches (38.4 x 25.7 cm.)
Signature: Tôshûsai Sharaku ga; *kiwame* seal
Publisher: Tsutaya
Date: 1794
The Metropolitan Museum of Art, Harris Brisbane Dick Fund, 1949

Sharaku brings us up so close to the two figures depicted here that nothing of the exchange going on between them can escape us. There is something unrelenting in the intensity with which he forces us to focus on the two men, so that their features are revealed almost as though under magnification, the lean face, furrowed brow, and beak-like nose of the one, the broad jowls, narrowed eyes, and stubborn set of the mouth of the other. Every last detail bespeaks character; nothing is superfluous. This print is surely one of Sharaku's masterpieces; yet, interestingly enough, the scene depicted was apparently only a minor one in the play it occurred in.

Former Collection: Kawaura
Reproduced: Vignier and Inada, *Kiyonaga, Bunchô, Sharaku*, No. 286; Kawaura Sale Catalogue, No. 363; Noguchi, *Tôshûsai Sharaku*, Pl. 38; U.T., Vol. VIII, No. 43; Rumpf, *Sharaku*, No. 27; Ledoux, *An Essay on Japanese Prints*, Pl. 5; Henderson and Ledoux, No. 29; Ledoux, *Sharaku to Toyokuni*, No. 21; Gentles, *Masters of the Japanese Print*, No. 81; Stern, *Master Prints of Japan*, No. 127

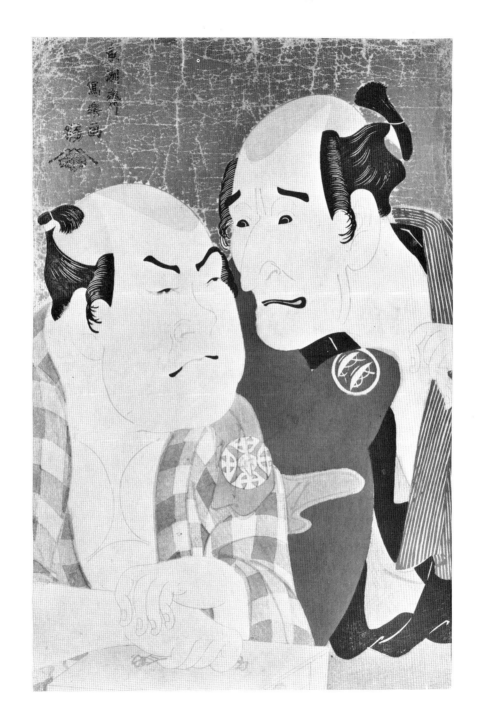

46 Eishôsai Chôki
THE COURTESAN TSUKASA-DAYÛ OF THE HIGASHI ÔGI-YA, SHINMACHI, OSAKA

ôban, 14⅝ x 10 inches, (37.1 x 25.4 cm.)
Signature: Chôki ga; *kiwame* seal
Publisher: Tsutaya
Date: ca. 1792
Prints Division, The New York Public Library, Astor, Lenox, and Tilden Foundation

Chôki has left a handful of prints that in their daring stylization remind one of Modigliani. They are all half-length portraits set against mica backgrounds, the subjects are famous courtesans of the time. There is invariably something exotic, even extreme, in Chôki's treatment of these *bijin*. Here, as in most of these prints, the courtesan's shoulders are impossibly narrow, her coiffure, with its stiff hairpins and translucent combs, improbably elaborate. In contrast with the next two prints, the mica background here is used primarily for the stylishness of its effect.

Former Collection: Haviland
Reproduced: First Haviland Sale Catalogue, No. 336; Ledoux, *Sharaku to Toyokuni,* No. 28

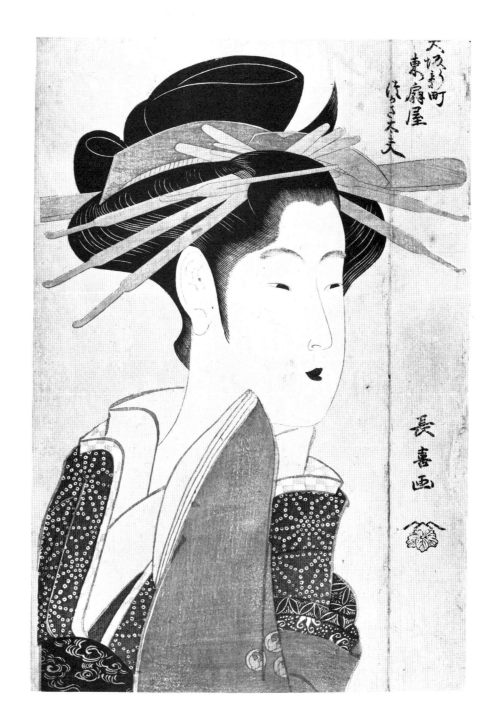

47 **Eishôsai Chôki**
TWO WOMEN SEATED BY A STREAM

ôban, 15 x 10 inches (38.1 x 25.4 cm.)
Signature: Chôki ga; *kiwame* seal
Publisher: Tsutaya
Collector's Seal: Hayashi
Date: ca. 1794
The Art Institute of Chicago, Clarence Buckingham Collection

"The great prints signed Chôki," Ledoux said "have an ethereal quality about them—a grace, a delicacy of feeling, a distinctive coloring—that is difficult to define or describe, but is as unmistakable as it is exquisite." Here is a perfect example of the kind of print that Ledoux must have had in mind. What makes it most remarkable is, of course, the way the mica is used to create an almost palpable sense of moonlight suffusing through the thin streamside vapors and mists of a hot summer evening. The woman at left wears a thin, gauze robe; a fan, unused, lies in her lap. The tranquility of the scene is underlined somehow by the quiet way the woman at right bends over to light her pipe.

Former Collections: Hayashi, Haviland, F. E. Church
Reproduced: Ledoux, *Sharaku to Toyokuni,* No. 29

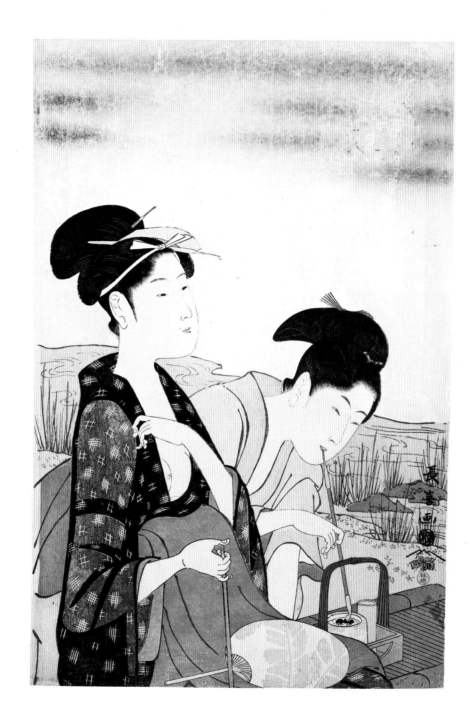

48 Eishôsai Chôki
A WOMAN AND A CHILD CATCHING FIREFLIES

ôban, 14⅝ x 9⅛ inches (37.2 x 23.2 cm.)
Signature: Chôki ga
Publisher: Tsutaya
Date: ca. 1793
The Art Institute of Chicago, Clarence Buckingham Collection

Here again Chôki uses a mica background to create an almost palpable sense of atmosphere; but this time the mica becomes the dense black sky of a moonless night. A woman and a boy are out hunting fireflies beside an iris pond. The woman, more an onlooker than a participant, indolently holds a tiny cage and a fan, while the child eagerly reaches up after one of the glowing insects.

Few, if any, of Chôki's designs can match this one for sheer magic. This particular impression is not the finest of those known, and there is a scarcely visible repair on the woman's face where someone once—long before it had come into Ledoux's possession—dropped a hot ash on it; but, as Ledoux himself said, "these are very minor faults in a print of the utmost rarity and of supreme elegance."

Former Collection: Koechlin
Reproduced: Vignier and Inada, *Yeishi, Chôki, Hokusai*, No. 114; Aubert, *Les Maîtres de l'Estampe Japonaise*, Pl. 31; Ledoux, *Sharaku to Toyokuni*, No. 30

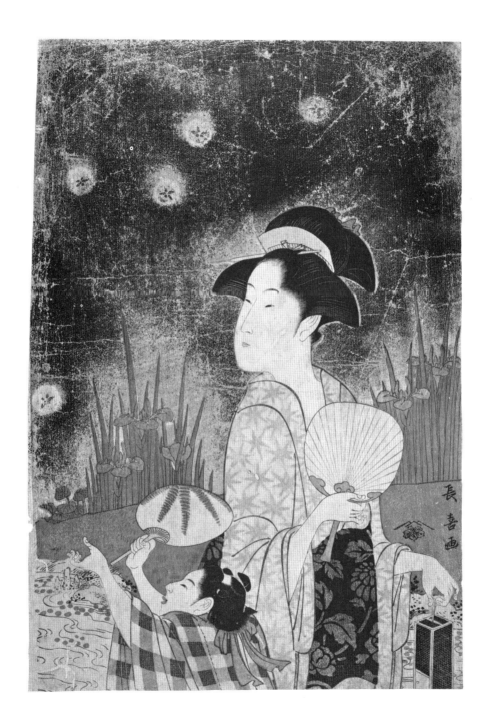

127

49 Katsukawa Shunei
DANJÛRÔ V AS TOKUBEI, THE FROG MAN

hosoban, 13 x 6 inches (33 x 15.3 cm.)
Signature: Shunei ga
Date: 1787
Mr. and Mrs. Richard Gale

Shunei was among the most original of Shunshô's many pupils, and this is surely one of the most arresting of his *hosoban* designs. He has placed Danjûrô athwart a stream, sword drawn, as though defending with his very life the sluice gate behind him. As the legendary Tenjiku Tokubei he wears a mottled frogskin under his robes, which are themselves decorated with seaweed. The swirling water, Danjûrô's loose, streaming hair, and the agitated folds of his garments contrast forcefully with the resolute firmness of his stance and the stout timbers of the sluice gate. The print is beautifully engraved and unusual in color.

Reproduced: Ledoux, *Grolier Figure Print Catalogue*, Pl. 19; Ledoux, *Sharaku to Toyokuni*, No. 31; Hillier, *Gale Catalogue*, No. 115

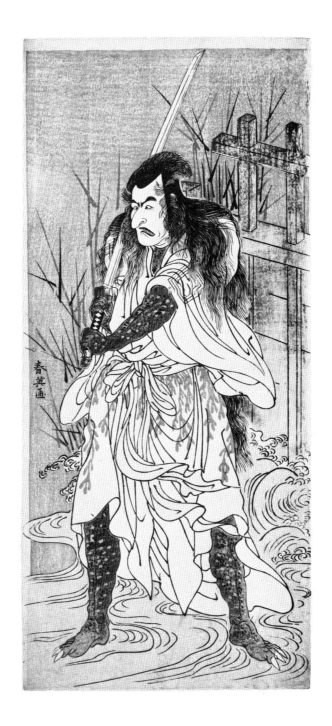

50 Chôbunsai Eishi
THE COURTESAN HANA MURASAKI OF THE TAMAYA, DÔCHÛ NO ZU, "HER PICTURE OUT WALKING"

from the series: *Seirô Bisen Awase*, "A Suite of Selected Beauties of the Green Houses," *ôban*, 15¼ x 9⅞ inches (38.7 x 25.1 cm.)
Signature: Eishi giga, "drawn for amusement by Eishi"
Publisher: Iwatoya
Date: ca. 1794
Mr. William W. Collins

The courtesan, standing alone, clad in all the finery of her calling, was one of the principal subjects of *ukiyo-e* from the start. One need only think back to the six Kaigetsudô prints included in this exhibition (Nos. 5-10) to be reminded of that fact. A comparison of this print by Eishi with, say, No. 9 by Kaigetsudô Doshin makes clear the extent to which the two artists were part of the same tradition, yet the differences between the two works are equally obvious. The elongated figure and elegant slouch of the Eishi *oiran*, the fashionable extravagance of her *obi*, bespeak a *fin-de-siècle* sophistication that seems far removed from the unabashed vigor apparent in the Kaigetsudô design. The refinement characteristic of all of Eishi's work is perhaps particularly evident here, especially in the handling of color. The pale brown of the mica background—Ledoux described it as "café au lait" in tone—is quite unusual, and the gradation of color on the courtesan's outermost kimono, from white through pale blue to purple, creates an effect one is more apt to associate with *ukiyo-e* painting than with prints.

This impression has traditionally been considered to be the third state of this print. Four states of each of the prints making up this series have been recognized, but there is some question as to how these states should be ordered. Ledoux, in his *Sharaku to Toyokuni* catalogue, discussed the problem at some length. More recently, Dr. Harold P. Stern, in his *Master Prints of Japan,* also addressed himself to the question.

Reproduced: Ledoux, *Sharaku to Toyokuni*, No. 42

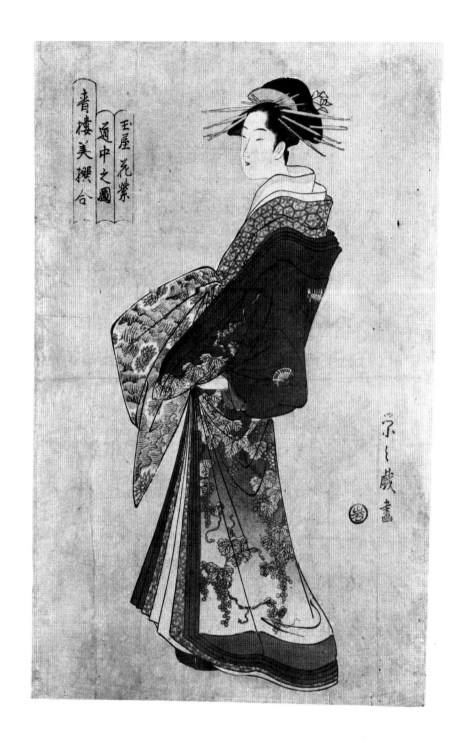

青
楼
美
撰
合

道
中
之
圖

玉
屋
花
紫

宗
之
歳
画

131

51 Eiri
THE NOVELIST SANTÔ KYÔDEN

from the set: *Edo no Hana*, "Flowers of Edo," *ôban*, 14½ x 10¼ inches (36.8 x 26 cm.)
Signature: Eiri ga
Date: ca. 1794
Ruth Stephan Franklin

Portraits, at least as we think of them in the West, are surprisingly rare in 18th century *ukiyo-e*. Shunshô and his followers, it is true, achieved considerable success in producing likenesses of popular *kabuki* actors, but they rarely went beyond setting down only the most easily recognizable external features of their subjects. Theater, after all, was their concern, not portraiture. As for the so-called portraits of Kiyonaga or Utamaro or even Chôki, it is obvious that they have only the most tenuous of connections with their supposed sitters. Only Sharaku, whose pictures are scathing almost to the point of caricature, and Eiri, who designed this disarming print, ever came close to creating portraits in our sense of the word.

Santô Kyôden (1761-1816), under the name of Kitao Masanobu a print designer himself, was a noted habituée of the select circle of Edo artists and writers whose lives typified the spirit of the "floating world." He was a poet as well as a novelist, and his satirical poems, *kyôka*, appear in many prints and paintings of the time. This portrait seems to show him as a clever but open and engaging sort of person. The cartouche bears, besides the series title, *Edo no Hana*, the more specific title, *Kyôbashi Natori*, "Celebrity of Kyôbashi." Inscribed on the fan at the lower right is a verse: *Saigyô mo/Mada minu hana no/Kuruwa kana*, "Such flowers as these never were seen in the past, even by Saigyô." Saigyô was a medieval poet priest famous for his poems in praise of cherry blossoms; but the "flowers" referred to here are more likely to mean the beauties of the pleasure quarters.

Eiri himself is something of a mystery, a mystery compounded by the fact that two different artists may have used this name. It is assumed that the artist we are concerned with here was a pupil of Chôbunsai Eishi and that he designed only a limited number of prints, several of them of considerable distinction.

Former Collection: Haviland
Reproduced: Second Haviland Sale Catalogue, No. 341; Ledoux, *Sharaku to Toyokuni*, No. 44

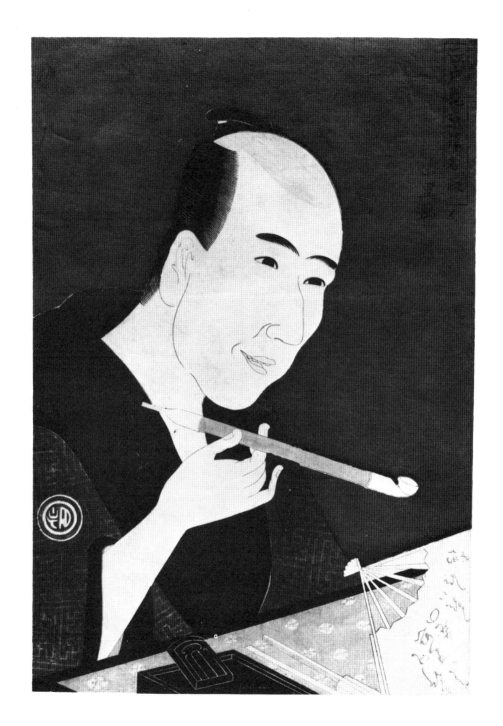

133

52 **Utagawa Toyokuni**
HALF-LENGTH PORTRAIT OF A GIRL IN SUMMER ROBES

from the series: *Fûryû Sambukutsui,* "Three Elegant Pictures," *ôban,* 14½ x
10 inches (36.8 x 25.4 cm.)
Signature: Toyokuni ga
Publisher: Izumiya
Date: ca. 1792
Private Collection

A print that for its sense of restraint, its air of classical composure, is unusual
in Toyokuni's *ouevre.* The lightness and transparency of the girl's cool sum-
mer robes are admirably rendered by the delicate printing, with which the
pale yellow background harmonizes beautifully. In such a setting, the rich
blacks of the girl's hair and the round lacquer tray become astonishingly
dramatic. The print is badly abraded along the bottom edge and is not in
perfect condition otherwise, but Ledoux was certainly right in considering it
one of Toyokuni's most distinguished designs.

Former Collection: Haviland
Reproduced: First Haviland Sale Catalogue, No. 369; Ledoux, *Sharaku to
Toyokuni,* No. 47; Popper Sale Catalogue, No. 238

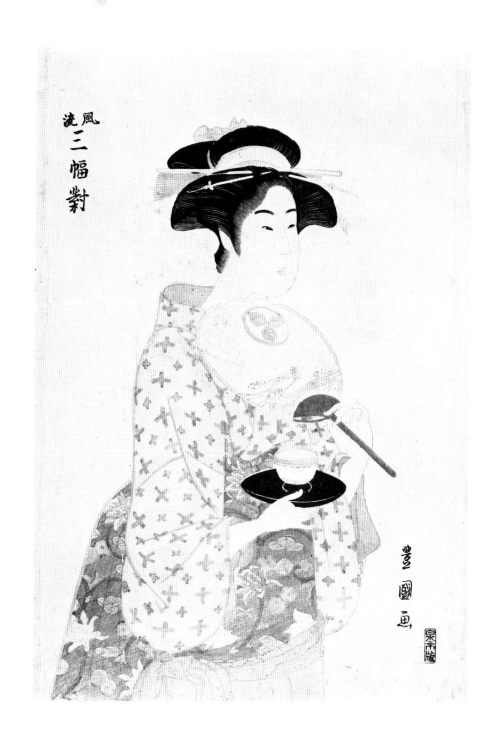

風
流
二
幅
對

豊
國
画

135

53 Utagawa Toyokuni
BUST PORTRAIT OF ICHIKAWA KOMAZÔ II

ôban, 14⅝ x 10 inches (37.1 x 25.4 cm.)
Signature: Toyokuni ga
Publisher: Uemura
Date: 1797
The Brooklyn Museum, Gift of Louis V. Ledoux

Though admitting that it was rare, and possibly even one of the best bust portraits by Toyokuni, Ledoux's praise of this print was qualified. "It is powerful in line," he wrote, "and a remarkable piece of printing. The hair above the ear is lacquered, the contours of the face and of the inner parts of the ear indicated without the use of a key-block by delicately tinted color. But what a falling off from Sharaku! The picture is intensely theatrical rather than intensely dramatic." Whether it is fair or not to consider this print a "falling off" from the work of Sharaku, the distinction Ledoux seems to be making here is probably valid. The faces in Sharaku's prints are so fascinating, so revealing psychologically, that one forgets that they belong to actors rather than to the characters whose roles the actors have assumed. Personality, and the implications of personality, are at the heart of Sharaku's concept of the stage. Toyokuni, however, subscribed to another tradition, one less concerned with character than with stylization. This tradition was particularly strong in *kabuki*, which was always more conventional than realistic and delighted in highly stylized movement and tableau-like effects. There is a sense, therefore, in which Toyokuni was probably more faithful to the spirit of Japanese theater than Sharaku.

Reproduced: Ledoux, *Sharaku to Toyokuni*, No. 48

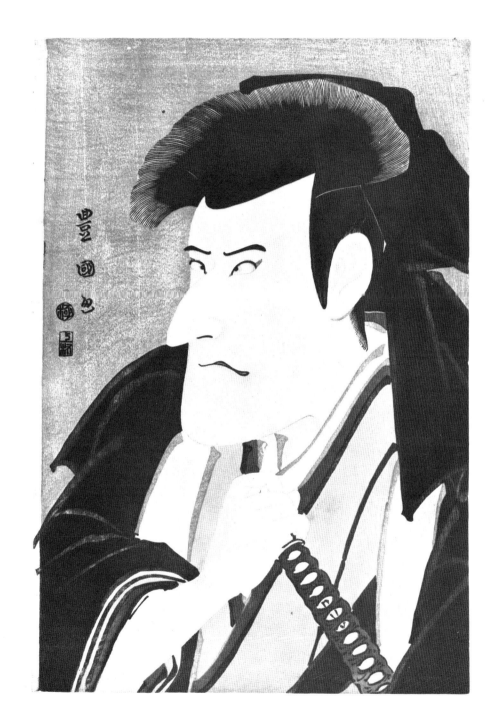

137

54 Shibata Zeshin
WHITE MICE

ôban yoko-e, 11¼ x 16⅞ inches (28.5 x 42.8 cm.)
Signature: Zeshin; Seal: Furumitsu
Date: ca. 1880
Mr. Roland Koscherak

Zeshin was a man of many talents. In the West he is best known as a lacquer artist, in Japan as a painter. His printed work consists largely of *surimono.* Interestingly enough, Zeshin is not an *ukiyo-e* artist; his early training was with the Shijô painter Suzuki Nanrei, and his work remained essentially Shijô in inspiration throughout his life. Ledoux was particularly fond of this print. What endears it to the collector, he said, "is its humorous and delightfully sensitive presentation of the mice. One can almost see their noses wiggle and their whiskers vibrate." The print is also, as Ledoux was quick to point out, "a minor masterpiece of composition and drawing and balance." Zeshin had a superb sense of design. Even the placement of his bold, splashy signature is studied and perfect.

Reproduced: Ledoux, *An Essay on Japanese Prints,* Pl. II; Ledoux, *Sharaku to Toyokuni,* No. 56

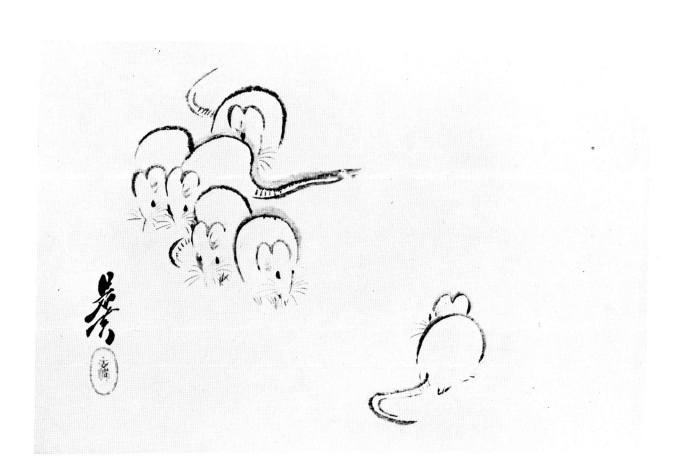

139

55 Katsushika Hokusai
CRANES ON A SNOW-LADEN PINE

kakemono-e, 20½ x 9⅛ inches (52 x 23.2 cm.)
Signature: Zen Hokusai I-itsu hitsu; *kiwame* seal
Publisher: Moriya
Date: early 1830's
Mr. and Mrs. Richard Gale

It was not until the 19th century that *ukiyo-e* artists finally broke away from the rather restricted range of subject matter they had been concerned with until that time, the *kabuki* theater and the pleasure quarters. Even then they did not turn to totally unexplored subject matter but rather to subjects that, previously, had been treated only by other schools of Japanese (and Chinese) painting. Pines and cranes, traditional symbols of longevity, are found on innumerable painted screens of the Kanô School, for instance, to cite but one of the older schools that had taken up the theme, the distant origins of which would have to be traced to Chinese antiquity. Hokusai, who was as voracious in his borrowings as Picasso, must have been well aware of this heritage and created a design in which, for all its forcefulness, the traditional elements are marked.

Reproduced: Ledoux, *Hokusai and Hiroshige,* No. 9; Hillier, *Gale Catalogue,* No. 241; Narazaki, *Zaigai Hihô, Hokusai,* No. 27

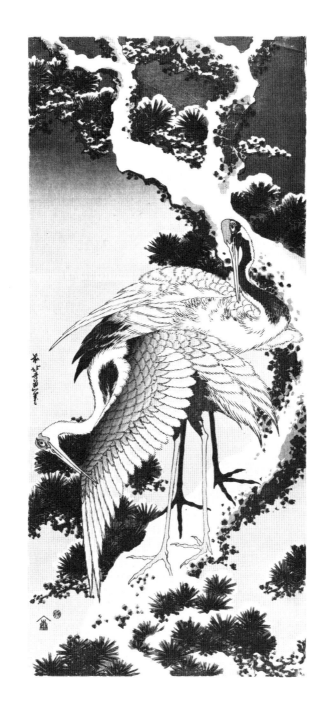

141

56 Katsushika Hokusai
FUJI ABOVE THE STORM

from the series: *Fugaku Sanjùrokkei,* "Thirty-Six Views of Mt. Fuji," *ôban-yoko-e,* 10 x 14⅝ inches (25.4 x 37.1 cm.)
Signature: Hokusai aratame I-itsu hitsu
Date: late 1820's
Mr. and Mrs. Richard Gale

Hokusai turned to the subject of Mt. Fuji at various times during his long, prolific career. He drew it in all kinds of weather and from every conceivable vantage point, from far out at sea or across miles of intervening plains, for instance, or occasionally from closer at hand, as here. Several of these designs stand out from all the rest, however; like the mountain itself they rise above even the tallest of neighboring peaks, brooking no comparisons. Among these few, "Fuji Above the Storm" (or "White Rain Under the Mountain," *Sanka Haku-u,* to give it its Japanese title) is surely one of the grandest in conception. Yet it is not, like so many of Hokusai's works, purely a product of the imagination. Anyone who has ever climbed a mountain probably has experienced the odd sensation of watching a storm pass by *beneath* him.

The "Thirty-Six Views" (to which ten supplementary views were soon added) were apparently a commercial success from the start. Editions were large, and, as a result, variations from impression to impression are marked. Some of the variations seem to be due to actual changes in the blocks, others merely to the different approaches of different printers. This impression seems to be early, though not before some wear had occurred in the thin lines framing the cartouche.

Reproduced: Ledoux, *Hokusai and Hiroshige,* No. 11; Hillier, *Gale Catalogue,* No. 227

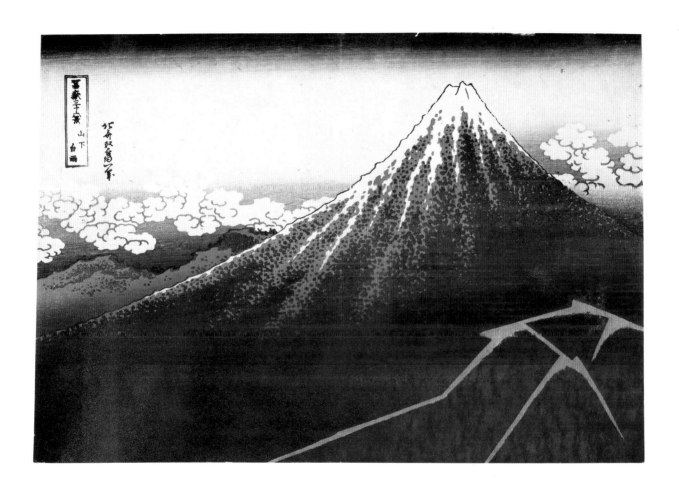

143

57 Katsushika Hokusai
FUJI FROM HODOGAYA ON THE TÔKAIDÔ

from the series: *Fugaku Sanjûrokkei,* "Thirty-Six Views of Mt. Fuji," *ôban yoko-e,* 10⅛ x 15⅞ inches (25.7 x 40.3 cm.)
Signature: Zen Hokusai I-itsu hitsu
Date: Late 1820's
Mr. and Mrs. Richard Gale

Here the mountain, though by its placement in the design still the central feature of the landscape, has receded in importance, framed between a straggling line of travellers below and a band of pine branches above. The rhythmic features of this design are marked. The curious hump-backed clusters of pine branches repeat, though in a somewhat flattened form, the shape of the mountain itself; the paired verticals of the tree trunks march at regular intervals across the picture. Everything speaks of motion, progression; one can almost hear the tread of the passersby; and the mountain is *glimpsed* more than it is seen, momentarily framed between two trees.

Former Collection: Blanchard
Reproduced: Blanchard Sale Catalogue, No. 191; Ledoux, *Hokusai and Hiroshige,* No. 12; Hillier, *Gale Catalogue,* No. 237

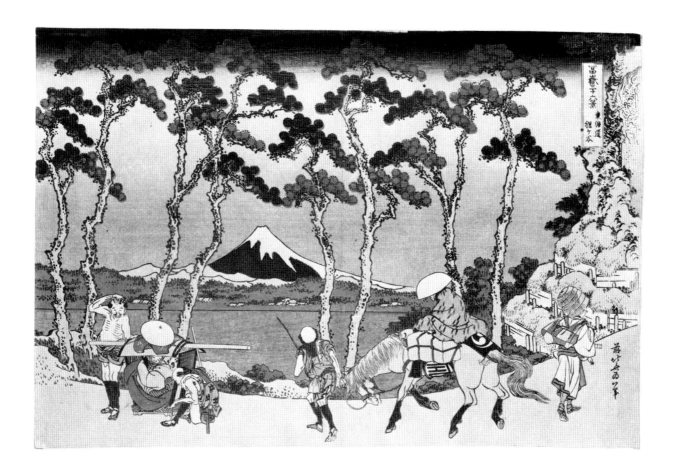

58 Ichiryûsai Hiroshige
HIRA NO BOSETSU, "EVENING SNOW ON MT. HIRA "

from the series: *Òmi Hakkei,* "Eight Views of Lake Òmi," *ôban yoko-e,* 9⅞ x
14½ inches (25.1 x 36.8 cm.)
Signature: Hiroshige ga; *kiwame* seal in margin
Publisher: Eikyûdô
Date: ca. 1835
Miss Edith Ehrman, New York

There is a grandeur, a vastness of scale, in the prints of this series that is
unusual even for Hiroshige. Perhaps in none of the prints is this more apparent
than here, where the few figures visible and the only signs of man's presence
are completely overshadowed by immense snow-covered mountains. The
nearer mountains, with their sharp ridges and dark, icy crevices, seem some-
how forbidding; yet the poem, printed in the cartouche at the left makes no
such suggestion: *Yuki haruru/Hira no takane no/Yûgure wa/Hana no sakari
ni/Suguru koro kana,* "At evening, when the snow has ceased falling at the
top of Mt. Hira, it is lovelier even than the cherry blossoms at their best."

Reproduced: Ledoux, *Hokusai and Hiroshige,* No. 26

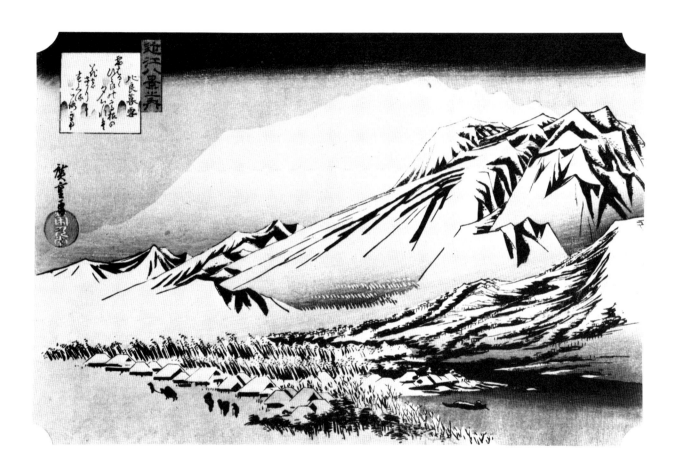

147

59 Ichiryûsai Hiroshige
YABASE NO KIHAN, "RETURNING SAILS AT YABASE"

from the series: *Ômi Hakkei,* "Eight Views of Lake Ômi," *ôban yoko-e,* 10 x 15 inches (25.4 x 38.1 cm.) including margins
Signature: Hiroshige ga; *kiwame* seal in margin
Publisher: Eikyûdô
Date: ca. 1835
Mr. and Mrs. James B. Austin

This, another of the classical Eight Views of Lake Ômi (today known as Lake Biwa), is from the same set as the last, and the scene, though less awesome, has something of the same breadth. It is sunset, and the sailboats at right all but disappear in the glittering reaches of the lake, while climbing mist, aglow in the after-light, envelops the base of the distant mountain. The poem in the cartouche at upper right reads: *Maho kakete/Yabase ni kaeru/Fune wa ima/ Uchide no hama o/Ato no oi kaze,* "Under full sail, running before the wind from Uchide Beach, the boats are returning to Yabase." Ledoux calls this "as perfect an impression as I have ever seen," high words of praise coming from him, but obviously well deserved in this instance.

Reproduced: Ledoux, *Hokusai and Hiroshige,* No. 28

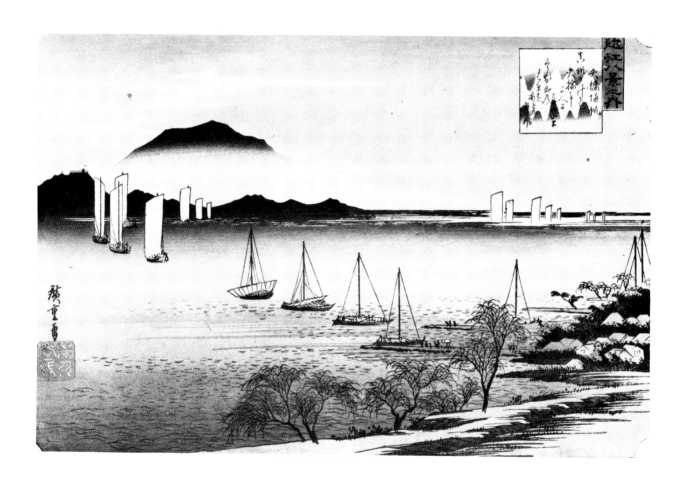

149

60 Ichiryûsai Hiroshige
GYÔTOKU SHIOHAMA NO ZU, "PICTURE OF THE SALT BEACH
AT GYÔTOKU "

from an untitled series of views of the environs of Edo, *ebangire,* 7 x 20 inches
(17.8 x 50.8 cm.)
Seal: Hiroshige hitsu
Date: ca. 1839
Mr. and Mrs. Edward H. Weinberg

The prints in this series are often referred to as Hiroshige's "long *surimono,*"
and indeed in technique, having been printed with the utmost care on soft,
absorbent paper, they do resemble those sumptuous works issued only for
special occasions. *Surimono,* however, invariably included poems referring to
the occasion for which they were brought out; these do not. In fact they were
intended, it seems, for letter writing. "It seems incredible," Ledoux wrote, "that
any letter writer would venture to inscribe his casual or ceremonious words on
such delicate works of art as these; yet the prevailing opinion is that the sheets
were designed for precisely this purpose. Doubtless they were used on special
occasions only, and not for ordinary letters; and we may even go so far as to
assume that the writing of a stately Chinese poem or an exquisitely turned
New Year's greeting, on the blank paper above the landscape, was not neces-
sarily as barbaric an intrusion as our ignorance of beautiful calligraphy might
lead us to fear." For all its delicacy there is a breadth to this landscape that is
remarkable. Ledoux considered it one of the most notable landscape prints in
his collection.

Reproduced: Ledoux, *Second Grolier Club Catalogue,* Pl. 7; Ledoux, *Hokusai
and Hiroshige,* No. 34

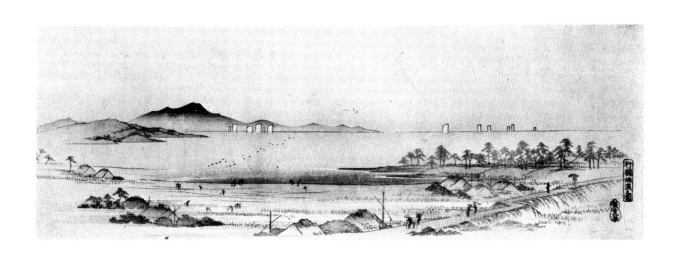

151

61 Ichiryûsai Hiroshige
A BIRD AND POPPIES

small *tanzaku*, 13⅝ x 4½ inches (34.6 x 11.4 cm.)
Signature: Hiroshige hitsu; seal: Ichiryûsai
Date: ca. 1836
Dr. David C. Kimball

Bird and flower subjects have a venerable tradition in the Orient, a tradition to which Hiroshige owed much; yet nothing could seem fresher, more spontaneous, than this. The one poppy seems so perilously poised on its tall, slender stalk that one expects it to break off at any moment. The verse, a *haiku*, in the upper left corner bears out this thought: *Tori tonde/Abunaki keshi no/ Hitoe kana*, "A single poppy, endangered by the bird's swift flight."

Reproduced: Ledoux, *Hokusai and Hiroshige,* No. 37

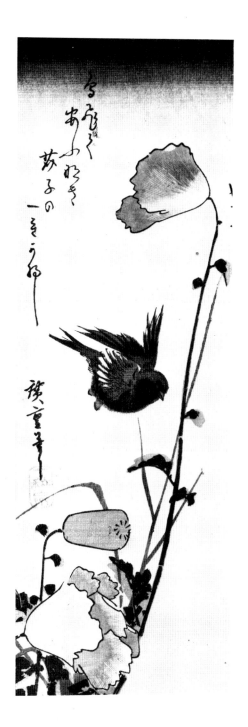

62 **Ichiryûsai Hiroshige**
SNOWY MOUNTAIN

from the series: *Wakan Rôei Shû,* "Japanese and Chinese Poems for Recitation," *ôban,* 14⅞ x 10⅛ inches (37.8 x 25.7 cm.)
Signature: Hiroshige hitsu; Artist's Seal: Ichiryûsai; *kiwame* seal
Publisher: Jôshûya Kinzô
Date: early 1840's
H. George Mann

There is something compelling about this picture: one almost overlooks at first the two small figures making their way across the bridge, for the real subject of this print is the mountain which looms ghost-like in the background, half disappearing in the thickening snow. *Sansui,* "mountains-and-water," is the Sino-Japanese term for landscape; and behind this picture lies the experience of centuries of painting during which the loftiest theme an artist could undertake was the mountain. The characters inscribed in the upper left corner are the first two lines of a poem by the T'ang Dynasty poet Po Chü-i (772-846). Ledoux translated them as follows: "The snow, like feathers of wild geese, flies and scatters about. Men, in the dress of white cranes, stand still or wander about." These lines underscore the fact that the mountains of Chinese painting, mountains of the imagination rather than of a specific place, are intended here.

Reproduced: Ledoux, *Second Grolier Club Catalogue,* Pl. 10; Ledoux, *Hokusai and Hiroshige,* No. 52

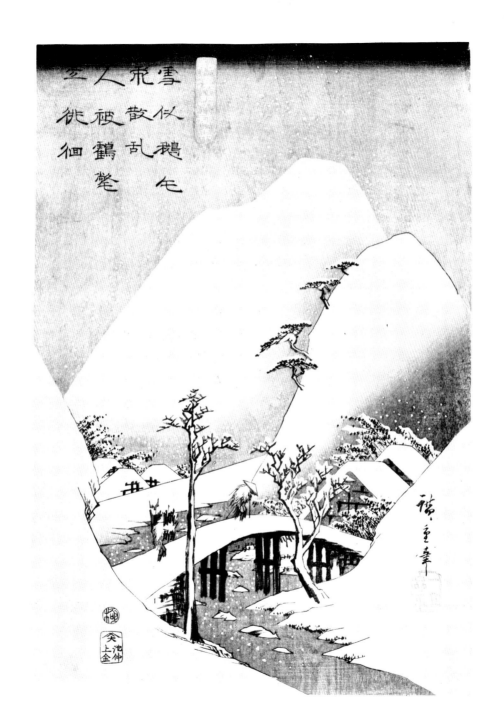

155

GLOSSARY

baren a circular pad used to press the print paper against the inked block.

beni a pink dye extracted from the *beni* flower (safflower— *Carthamus* tinctorus).

beni-e prints with brush-added color in which *beni* predominates.

benizuri-e prints with block-printed color, in which the colors are usually limited to *beni* and green.

bijin a beautiful woman, "a beauty."

calendar print prints in which cryptic references are made to the pattern of long and short months appropriate to a specific year. In the old calendrical system prevailing in Japan prior to the late 19th century, this pattern varied from year to year by official decree. Calendar prints were particularly popular during the second and third years of the Meiwa Era (1765 and 1766).

chûban a medium size print, roughly 11 x 8 inches (28 x 20 cm.).

Edo the old name for Tokyo; the seat of the shogunate during the Tokugawa (or Edo) Period (1615-1868).

ga "painted by"; often follows an artist's signature.

gauffrage blind printing; embossing achieved by printing from uninked blocks.

haori a half-length outer robe or jacket.

hashira-e literally, "pillar picture"; a tall narrow print varying in size from about 26 x 4 inches (66 x 10 cm.) to 27 x 6 inches (68.5 x 15 cm.).

hitsu literally, "brush"; i.e., by the brush of; often follows an artist's signature.

hosoban a narrow size print, roughly 12½ x 5½ inches (31.5 x 14 cm.).

kakemono-e a large print roughly 22 x 12 inches (56 x 30.5 cm.), a standard size in the early Primitive Period.

kakihan literally, "written seal"; a brush-drawn cypher sometimes added to an artist's signature in lieu of a seal.

Kansai	literally, "West of the Barrier"; West Japan—i.e., the area including Kyoto and Osaka—as distinguished from the region around Edo.
kiwame seal	a round seal enclosing the character *kiwame*, meaning "adjudged" or "examined"; a censor's seal in use from 1791 to 1842.
mitate-e	a print making use of a contemporary "equivalent" of classical subject matter; often, but not necessarily, taking the form of a parody or travesty.
mon	an insignia or crest inherited like a coat-of-arms and important in the study of *ukiyo-e* as a means of identifying actors.
ôban	a large size print, roughly 15 x 10 inches (38 x 25.5 cm.).
obi	the elaborate sash worn with kimono.
oiran	a high-ranking courtesan.
onnagata	an actor specializing in women's roles.
Shijô School	one of the major schools of Japanese painting during the 19th century, founded by Goshun (1752-1811).
shôji	a sliding paper door.
shunga	literally, "spring pictures"; erotic pictures.
surimono	a deluxe print brought out in a limited edition for a special occasion, usually inscribed with poetry specifically composed for that occasion.
tan	red lead.
tan-e	a primitive print in which brush-added *tan* predominates.
urushi-e	a hand colored print in which transparent glue is used to create a lacquer-like effect.
wakashu	a young dandy, often a homosexual.
yoko-e	literally, a "horizontal picture."
Yoshiwara	the best known of the Edo pleasure quarters.
zôri	a straw sandal.

BIBLIOGRAPHY

Aubert, Louis. *Les Maîtres de l'Estampe Japonaise.* Paris, 1914.

Blanchard Sales Catalogue: *Illustrated Catalogue of the Notable Collection of Japanese Color Prints, The Property of Mrs. John Osgood Blanchard.* American Art Galleries, New York, 1916.

Chavarse Sale Catalogue: *Estampes Japonaises Appartenant 1) à Monsieur C..., 2) à divers Amateurs.* Hôtel Drouot, Paris, February 15th and 16th, 1922.

Ficke, Arthur D. *Chats on Japanese Prints.* London and New York, 1915.
——————————. "The Prints of Kwaigetsudô," The Arts (New York) IV, No. 2 (1932), pp. 95-119.

Ficke Sales Catalogue: *The Japanese Print Collection of Arthur Davison Ficke.* The Anderson Galleries, New York, 1925.

Fujikake, Shizuya. *Ukiyo e no Kenkyû.* Tokyo, 1943.

Garland Catalogue: *Japanese Prints Collected by the Late Mr. and Mrs. H. P. Garland, Saco, Maine.* Parke-Bernet Galleries, Inc., New York, 1945.

Gentles, Margaret O. *The Clarence Buckingham Collection of Japanese Prints, Vol. II: Harunobu, Koryûsai, Shigemasa, Their Followers and Contemporaries.* The Art Institute of Chicago, 1965. (Abbreviated to AIC II)
——————————. *Masters of the Japanese Print: Moronobu to Utamaro.* New York, 1964.

Gonse Sale Catalogue: *Collection Louis Gonse. Oeuvres D'Art Du Japon.* Hôtel Drouot, Paris, 1924.

Haviland Sales Catalogues: *Collection Ch. Haviland. Estampes Japonaises, Peintures des Écoles Classiques et de quelques Maîtres de l'Ukiyo-e. Première Vente.* Hôtel Drouot, Paris, November 1922.
——————————: *Collection Ch. Haviland. Estampes Japonaises (Deuxième Partie).* Hôtel Drouot, Paris, June 1923.
——————————: *Collection Ch. Haviland (Quatorzième Vente). Estampes Japonaises, Ceramique du Japon.* Hôtel Drouot, Paris, February 1924.

Henderson, Harold and Ledoux, Louis V. *The Surviving Works of Sharaku.* New York, 1939.

Hillier, Jack. *Utamaro: Colour Prints and Paintings.* London, 1961.

Hillier, Jack. *Japanese Colour Prints.* London, 1966.
 _____. *Suzuki Harunobu: An Exhibition of His Colour-Prints and Illustrated Books on the Occasion of the Bicentenary of His Death in 1770.* Philadelphia Museum of Art, 1970. (Abbreviated to *Harunobu Catalogue*)
 _____. *Catalogue of the Japanese Paintings and Prints in the Collection of Mr. and Mrs. Richard P. Gale.* The Minneapolis Institute of Arts, 1970. (Abbreviated to *Gale Catalogue*

Hirakawa Sale Catalogue: *Illustrated Catalogue of the Japanese Color Prints Forming the Private Collection of Kenkichi Hirakawa.* American Art Galleries, New York, March 1917.

Hirano, Chie. *Kiyonaga, A Study of His Life and Works.* The Museum of Fine Arts, Boston, 1939.

Inouye, Kazuo. *Sharaku.* Tokyo, 1940.

Jacquin Sale Catalogue: *Rare and Valuable Japanese Color Prints. The Noted Collection Formed by a Distinguished French Connoisseur of Paris.* Catalogue by Frederick Gookin. The Walpole Galleries, New York, 1921.

Jenkins, Donald. *Ukiyo-e Prints and Paintings: The Primitive Period 1680-1745. An Exhibition in Memory of Margaret O. Gentles.* The Art Institute of Chicago, 1971. (Abbreviated to *Ukiyo-e Primitives*)

Kawaura Catalogue: *Album of Old Japanese Prints of the Ukiyo-ye School. Reproduced from the Collection of Kenichi Kawaura.* Tokyo, Japan.

Kawaura Sale Catalogue: *Japanese Color Prints. The Splendid Private Collection of Mr. K. Kawaura of Tokyo.* Catalogue by Mr. Otto Fukushima. American Art Galleries, New York, 1925.

Lane, Richard. *Masters of the Japanese Print: Their World and Their Art.* New York, 1962.

Ledoux, Louis V. *A Descriptive Catalogue of an Exhibition of Japanese Figure Prints from Moronobu to Toyokuni.* The Grolier Club, New York, 1924. Abbreviated to *Grolier Figure Print Catalogue*)
 _____. *A Descriptive Catalogue of an Exhibition of Japanese Landscape, Bird, and Flower Prints and Surimono from Hokusai to Kyôsai.* The Grolier Club, New York, 1924. (Abbreviated to *Second Grolier Club Catalogue*)
 _____. *An Essay on Japanese Prints.* The Japan Society, New York, 1938.

Ledoux, Louis V. *Japanese Prints of the Primitive Period in the Collection of Louis V. Ledoux*, New York, 1942.
(Abbreviated to *Primitives*)
_____. *Japanese Prints by Harunobu and Shunshô in the Collection of Louis V. Ledoux*. New York, 1944.
(Abbreviated to *Harunobu and Shunshô*)
_____. *Japanese Prints, Bunchô to Utamaro, in the Collection of Louis V. Ledoux*. New York, 1948.
(Abbreviated to *Bunchô to Utamaro*)
_____. *Japanese Prints, Sharaku to Toyokuni, in the Collection of Louis V. Ledoux*. Princeton, 1950.
(Abbreviated to *Sharaku to Toyokuni*)
_____. *Japanese Prints, Hokusai and Hiroshige, in the Collection of Louis V. Ledoux*. Princeton, 1951.
(Abbreviated to *Hokusai and Hiroshige*)
Lee, Sherman. *Japanese Decorative Style*. The Cleveland Museum of Art, 1961.

Michener, James A. *The Floating World*. New York, 1954.
_____. *Japanese Prints: From the Early Masters to the Moderns. With Notes on the Prints by Richard Lane*. Rutland, Vermont and Tokyo, 1959

Mills College Catalogue. *Friends of Far Eastern Art, Second Exhibition: Japanese Art*. Mills College, California, 1936.

Münsterberg, Oskar. *Japanische Kunstgeschichte (Vol. 3)*. Berlin, 1908.

Mutiaux Sale Catalogue: *Objets d'Art d'Extreme Orient et Estampes Japonaises Appartenant à Divers Amateurs*. Paris, 1922.

Narazaki, Muneshige (ed.). *Zaigai Hihô, Harunobu*. Tokyo, 1972.
_____. *Zaigai Hihô, Hokusai.* Tokyo, 1972.
_____. *Zaigai Hihô, Tôshûsai Sharaku*. Tokyo, 1972.

Nihon Keizai Shimbun (ed.). *Ukiyo-e Masterpieces from The Art Institute of Chicago*. Tokyo, 1973.

Noguchi, Yone (-jirô). *Tôshûsai Sharaku*. Tokyo, 1925, 1930, 1932.
_____. *Harunobu*. Toyko, 1932.
_____. *The Ukiyo-e Primitives*. Tokyo, 1933.
_____. *Harunobu*. London, 1940.

Popper Sale Catalogue: *The Hans Popper Collection of Japanese Prints*. Sotheby Parke Bernet, Inc., New York, October 5th and 6th, 1972.

Rumpf, Fritz. *Sharaku*. Berlin, 1932.

Schraubstadter Sale Catalogue: *An Exceptionally Important Collection of Rare and Valuable Japanese Color Prints. The Property of Carl Schraubstadter.* American Art Galleries, New York, 1921.

Seidlitz, W. von. *Les Estampes Japonaises*. Paris, 1911.

Shibai Nishiki Shùsei. Selected Actor Prints. Tokyo, 1918.

Stern, Harold. *Master Prints of Japan, Ukiyo-e Hanga.* New York, 1969.

Suzuki, Jùzô. *Sharaku*. Tokyo, 1968.

Trotter, Massey. *Catalogue of the Work of Kitagawa Utamaro in the Collections of The New York Public Library.* Introduction by Harold G. Henderson. New York, 1950.

Ukiyo-e Art. "Special Ledoux Issue," (Tokyo), No. 9 (1965), pp. 1-20.

Ukiyo-e Taisei. Twelve Volumes. Tokyo, 1930-31. (Abbreviated to U.T.)

Ukiyo-e Taisei Shùsei. Twenty Volumes. Tokyo, 1931. (Abbreviated to U.T.S.)

Vignier, Charles and Inada, Hogitarô. *Estampes Japonaises Primitives Exposées au Musée des Arts Decoratifs en Fevrier, 1909.* Paris, February, 1909. (Abbreviated to *Primitives*)
_____. *Harunobu, Koriusai, Shunshô. Estampes Japonaises Exposées au Musée des Arts Decoratifs en Janvier, 1910.* Paris, January, 1910.
_____. *Kiyonaga, Bunchô, Sharaku. Estampes Japonaises Exposées au Musée des Arts Decoratifs en Janvier, 1911.* Paris, January, 1911.
_____. *Utamaro. Estampes Japonaises Exposées au Musée des Arts Decoratifs en Janvier, 1912.* Paris, January, 1912.
_____. *Yeishi, Choki, Hokusai. Estampes Japonaises Exposées au Musée des Arts Decoratifs en Janvier, 1913.* Paris, January, 1913.
_____. *Toyokuni, Hiroshige. Estampes Japonaises Exposées au Musée des Art Decoratifs en Janvier, 1914.* Paris, January, 1914.

Wright Sale Catalogue: *The Frank Lloyd Wright Collection of Japanese Antique Prints.* Anderson Galleries, New York, January, 1927.

FRIENDS OF JAPAN HOUSE GALLERY

Mrs. April Akston
*Mrs. Vincent Astor
*Mr. and Mrs. Douglas Auchincloss
Mrs. Harold L. Bache
*Mr. and Mrs. Armand P. Bartos
*Mr. Joe Brotherton
*Mr. and Mrs. Jackson Burke
*Mrs. Cornelius Crane
Mr. and Mrs. Lewis B. Cullman
*Mr. and Mrs. C. Douglas Dillon
*Mr. and Mrs. Peter F. Drucker
*Mr. and Mrs. Myron S. Falk, Jr.
*Mr. Charles A. Greenfield
*Mr. Louis W. Hill, Jr.
*Mr. and Mrs. William H. Johnstone
*Mr. Yale Kneeland III
*Mrs. Yale Kneeland III
Mrs. H. Irgens Larsen
*Mrs. Louis V. Ledoux
*Mr. and Mrs. Henry A. Loeb
*Mr. and Mrs. Stanley J. Love
Mr. and Mrs. Perry A. Pease
*Mr. and Mrs. Joe D. Price
*Mrs. John D. Rockefeller 3rd
*Mrs. Aye Simon
*Mr. and Mrs. Donald B. Straus
*Mrs. Arnold L. van Ameringen
*Mr. Richard W. Weatherhead
*Miss Lucia Woods

*Founder

162

Cover Illustration: Catalogue No. 47
Print entitled: "Two Women Seated By A Stream" by Eishôsai Chôki;
ôban, 15 x 10 inches (38.1 x 25.4 cm.); Date: ca. 1794;
The Art Institute of Chicago, Clarence Buckingham Collection
Catalogue designed by Kiyoshi Kanai
Catalogue numbers 19, 22, 23, 40, 50, 51,
54, 59, 60, 61 photographed by Otto E. Nelson;
all other photographs courtesy of the lenders
Composition by Franklin Typographers, New York
Printed and bound by Nissha Printing Co., Ltd., Kyoto, Japan